STICK FIGURES
The Life and Art of Len Boswell

Sticky Stickerson

PINNE ⚇ PINNE
Förlag

Copyright © 2020 by Len Boswell
All artwork copyright © 2018, 2019, 2020 by Len Boswell
Excerpt from *A Grave Misunderstanding* copyright © 2017, 2020
by Len Boswell
ISBN 978-1-08011-937-0

All Rights Reserved. No part of this publication may be reproduced, stored in a retrieval system, or transmitted, in any form or in any means—by electronic, mechanical, photocopying, recording or otherwise—without prior written permission.

Sticky Stickerson is a pen name of Len Boswell.

Despite what your lying eyes may be telling you, the art in this book is real. However, any resemblance of this art to any other art you may have seen before is totally laughable. In addition, the publisher hereby disavows this entire book, and wishes to hell it had never signed the damned contract. That said, it is important to know that no sticks were harmed in the writing of this book, save for a few arrogant stick models, who were summarily burned at the stake in a flagrant act of redundancy. Furthermore, the author would like to take this opportunity to thank trees everywhere for their contributions to this work. All right, end of disclaimer. Move along. Oh, but wait . . .

All the art in this book is for sale, either as 8 ½ x 11 originals or as high-quality art prints, at any size you might want. Inquire at simonsilverback@gmail.com .

To all I love without condition
To all I love without omission

Never doubt

And a special shout-out to *Sticklandia!*

Contents

Preface, vii
Introduction, ix

Part One: History and Techniques, 1
Part Two: Art with Words, 15
Part Three: Word Play, Stick Play, 37
Part Four: Boswell Re-creates the Masters, 59
Part Five: Original Art, 79
Part Six: A Miscellany of Fun, 133

Afterwords, 161
Excerpt, *A Grave Misunderstanding*, 163

Preface

The island nation of Sticklandia is shrouded in heavy fog, as it is year-round, much like Skull Island, the home of King Kong, a fact that explains the screams of my fellow passengers as the plane makes its near vertical descent to the tiny airstrip. I've grown used to the landing in Sticklandia's capital city (in fact, it's only city), Stickö, over the years. Previous visits to meet and interview Sticklandia's self-proclaimed "youngest and oldest" stick-figure artist, Len Boswell, have steeled me to the G-forces of the headlong descent required for a safe landing.

Moments later, the six of us deplane, at least five a bit wobbly and more than ready for a herring martini at the island's one motel, Stickler Express, which is partially owned by Boswell. All flights to Sticklandia arrive at happy hour, so my fellow passengers will also enjoy half-price bar fare involving herring and horseradish. I tell them I'd be happy to join them, but I have other plans.

I've been working on this little book for more than six years, trying to piece together, work by work, Boswell's complete catalog. Alas, I learned very quickly that most of his stick-figure drawings are no more. Hundreds were burned in the hotel fire of 1956. An estimated 500 more were used to wrap take-out herring and chips over the years. And more than a thousand were swept up in the origami craze of 2014.

Fortunately, Boswell has been more than forthcoming with his most recent works, so you can expect to see more than 150 of Boswell's best, along with a few rare early works.

As always, Boswell greets me at the door to his palatial home in a bathrobe and flip-flops, a herring martini in one hand for me, and a herring fizz in the other hand for himself. He has grown exponentially older these last six years. He is bald, but what hair he has extends to the middle of his back, and his matching white beard almost touches his chest. Only his hypnotic blue eyes remain the same, binding anyone who fixes on them with his inner mirth. I can tell by the way he winks at me that we have several new works to discuss.

But before we do that, let's start at the beginning. Where did stick figures begin, and how did the Art Sticko Movement develop? Stick with me. It's going to be quite a ride.

—Sticky Stickerson

Introduction

No discussion of Boswell and his art can begin without first considering, at least briefly, the history of Sticklandia itself, for it is in this cauldron of fog and sticks that the young Boswell was formed.

Herring in the Fog

Sticklandia is the largest island in an archipelago of islands known as the Seven Sticks, all of which were formed eons ago by a massive underwater eruption. Volcanic activity continues even today, and is the principal reason for the impenetrable fog surrounding the island, cool air meeting warm water with predictable results.

Sticklandia's population, which as of this writing totals 632, are all descendants of two shipwrecked children, Sticker and Stickee, the lucky infants who climbed from the sea to be greeted by Sticklandia's major resources, sticks and stones. Yes, the phrase "sticks and stones may break your bones" originated here, as did the sport of stickball and all stick words, from stick to stickler to stickum to stickup and beyond. And, as you have probably guessed from my name, I am also a proud Sticklandian.

Fortunately for Sticker and Stickee, they also found an abundance of herring in the waters surrounding the island, and quickly set about perfecting ways to catch them. Fishing from the cliffs was perilous, and fishing in boats was out of the question, so they began to mine fish. Using only sticks, they dug deep shafts through the rocky soil until they reached the sea and its bounteous herring.

Even today, herring are harvested in this way, the fish carted to the surface in stick baskets and then, as is the custom, beaten senseless with sticks before being thrown into the cooking pot. The process gives the herring a unique taste unlike anything else in the world. And yes, fish sticks were invented here.

A Language in Sticks

As the population grew, the need for a written language increased. Finally, more than two hundred years after Sticker and Stickee were washed ashore, a young stickergirl put sticks together to form a rudimentary alphabet not unlike hieroglyphs or runes. Unfortunately, few took up the written language. Gathering sticks, sorting them in size, and then forming the runes was tedious. Often, by the time the words were spelled out, the moment had passed. Even today you will find evidence of this in the outback areas of Sticklandia, where it is not uncommon to come upon an array of sticks that simply says, "Oh, never mind."

Fortunately, just fifty years later, the invention of the sticking press changed everything, and people could finally stick down their thoughts and communicate them to their fellow citizens and the world.

Which brings us to the work at hand.

An Artist is Born

Len Boswell claims he was born a fully formed man, over six feet tall and [in his words] "handsome as all get-out." The evidence suggests otherwise, of course, even though the first seventy years of his life remain shrouded in mystery save for a few surviving examples of his stick-figure art.

Which brings us to today and our discussion of the man's art. I have divided the works into six parts:

Part One: History and Techniques
Part Two: Art with Words
Part Three: Word Play, Stick Play
Part Four: Boswell Re-creates the Masters
Part Five: Original Art
Part Six: A Miscellany of Fun

In each section, I will provide commentary on the meaning of the art and its significance to the Art Sticko Movement, together with the artist's own comments about his art.

I hope that this approach will adequately introduce and illuminate the man and his art to a wider world, and thereby generate the praise he so stickly deserves. If not, then, "never mind."

Part One
History and Techniques

Stick art developed naturally in Sticklandia, as it did in the rest of the world. Unlike the rest of the world, however, where stick art was seen as childish and hopefully quickly left behind, Sticklandia viewed stick-figure art as the ultimate expression. To a Sticklandian, the idea of improving on stick-figure art, taking it to some mythical higher level, is just ridiculous.

Stick art is everything. Stick art is all. And no one did it better, or does it better, than Len Boswell. Period. End of discussion. Time to move on.

Ahem.

Throughout his career, Boswell has strived to pass along his knowledge to new generations of stick-figure artists. Sadly, many of the drawings he used in his elementary and master courses in stick-figure art were lost in the Great Fire. The drawings that remain, although providing an incomplete picture of the art and techniques of stick-figure drawing, do highlight his absolute mastery. Here, in fourteen drawings, you will find the essence of stick-figure art. The lines. The composition. The nuance. The splendor in the sticks.

STICK FIGURES

STICK FIGURES
THE NUANCES OF SADNESS

SAD	GLUM
MELANCHOLY	BLUE
WOEBEGONE	SMILE, DAMMIT!

Stick-Figure Emotocons, Series 2

STICK FIGURES

"Stick Theory" 2019

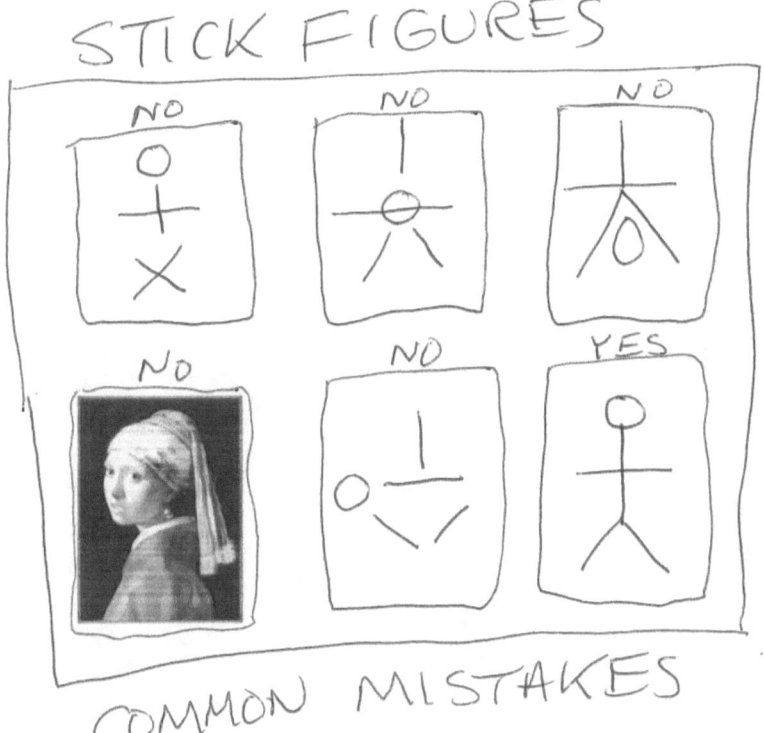

STICK FIGURES

STICK FIGURES

STEP ONE Assemble sticks	STEP TWO Boil water	STEP THREE Add one long stick to water
STEP FOUR Boil until stick is soft	STEP FIVE Remove stick	STEP SIX Form head
STEP SEVEN Try again	STEP EIGHT And again	STEP NINE Success!

How to draw a head

STICK FIGURES

STICK FIGURES

IMPRESSIONISM

SURREALISM

CUBISM

ABSTRACT EXPRESSIONISM

STICK MOVEMENTS

STICK FIGURES

STICK FIGURES ART LESSONS

He stood there, every fiber of his being coiling in anger, ready to strike with a vengeance of inestimable furor.

J.Buell

Lesson Six: Matching Art with Emotion

STICK FIGURES

FUTURE IMPERATIVE

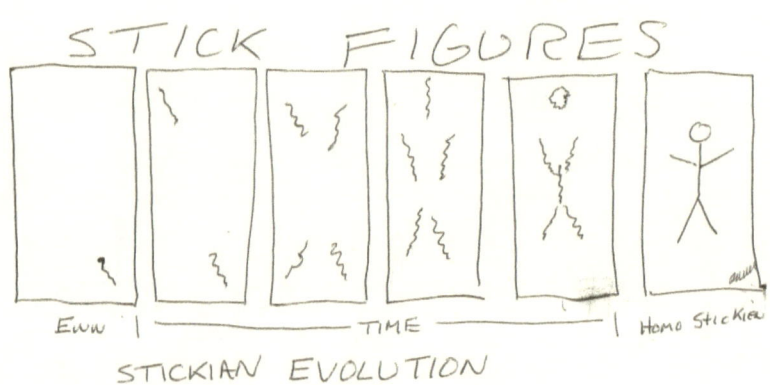

STICKIAN EVOLUTION

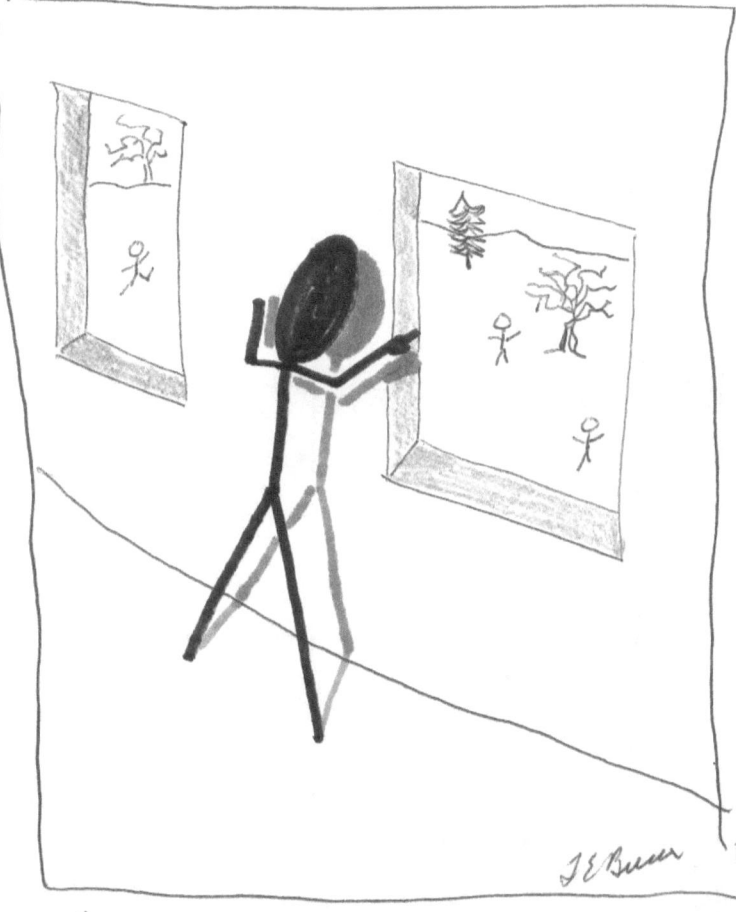
"Shadow Study"

STICK FIGURES

STICKY STICKERSON — BOSWELL — A life in Art

| AGE 3 | AGE 75 |

"Age Gap"

Part Two
Art with Words

Boswell is a lover of line, and words. Joining them together, as he has done in the stick-figure art in this section, was his way of being at once funny and profound.

Some of these drawings made me laugh out loud; others made me smile, knowing the truth of his words; and still others made me cry for my mommy. Boswell is like that. Never afraid to wring out every ounce of emotion in a drawing.

The twenty-one drawings in this section will literally fly by if you're not careful. But I encourage you to linger on each one, absorb it in its entirety, savor its every nuance, and embrace its transformative message.

Okay, move along.

STICK FIGURES

STICK FIGURES

> **STICK FIGURES**
>
> **DAVIDA'S BAD VERY BAD AWFUL FRICKIN' FLIGHT**
>
> By the author of:
> *Middle Seat Monster!*
> and
> *This Plane is Mine!*
>
> SOON TO BE A MAJOR MOTION PICTURE. WATCH THE SKIES!

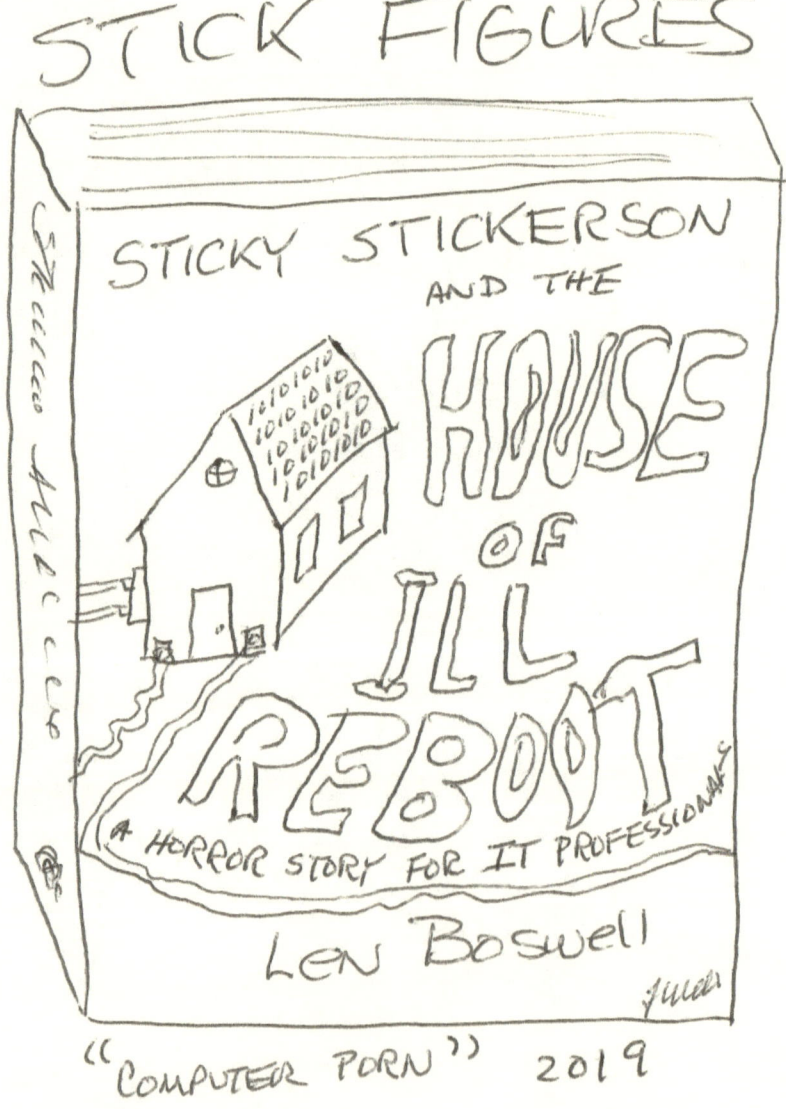

STICK FIGURES

> "The fabric of every society contains the pull threads for its unraveling."
>
> — J.E. Boswell

"An Undoing in Orange"

STICK FIGURES

Sunlight streamed into the room, unbidden, uninvited, and clearly without tickets.

sunlight

STICK FIGURES

> Life was his oyster, albeit an oyster that had slipped off its half shell and landed on the hood of an overheated car hurtling toward a cliff known for its lack of empathy...
>
> UH-OH

"Good News, Bad News"
Life Is #1

"Life Is" #3
"Life is like a Book"

STICK FIGURES

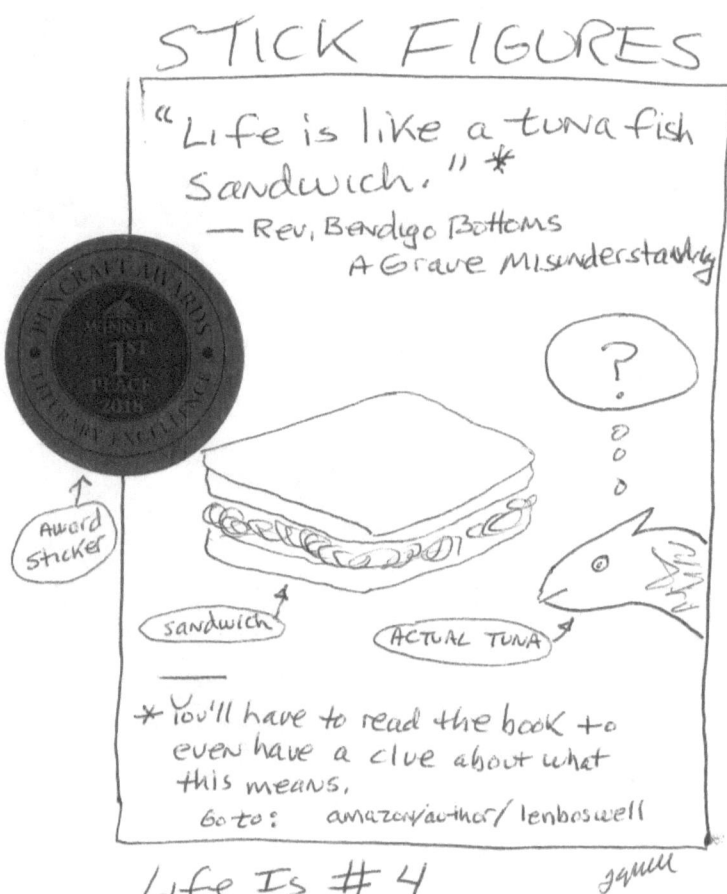

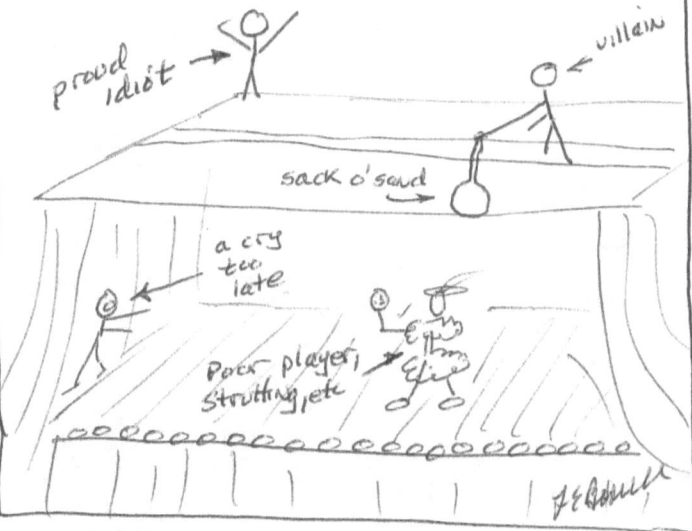

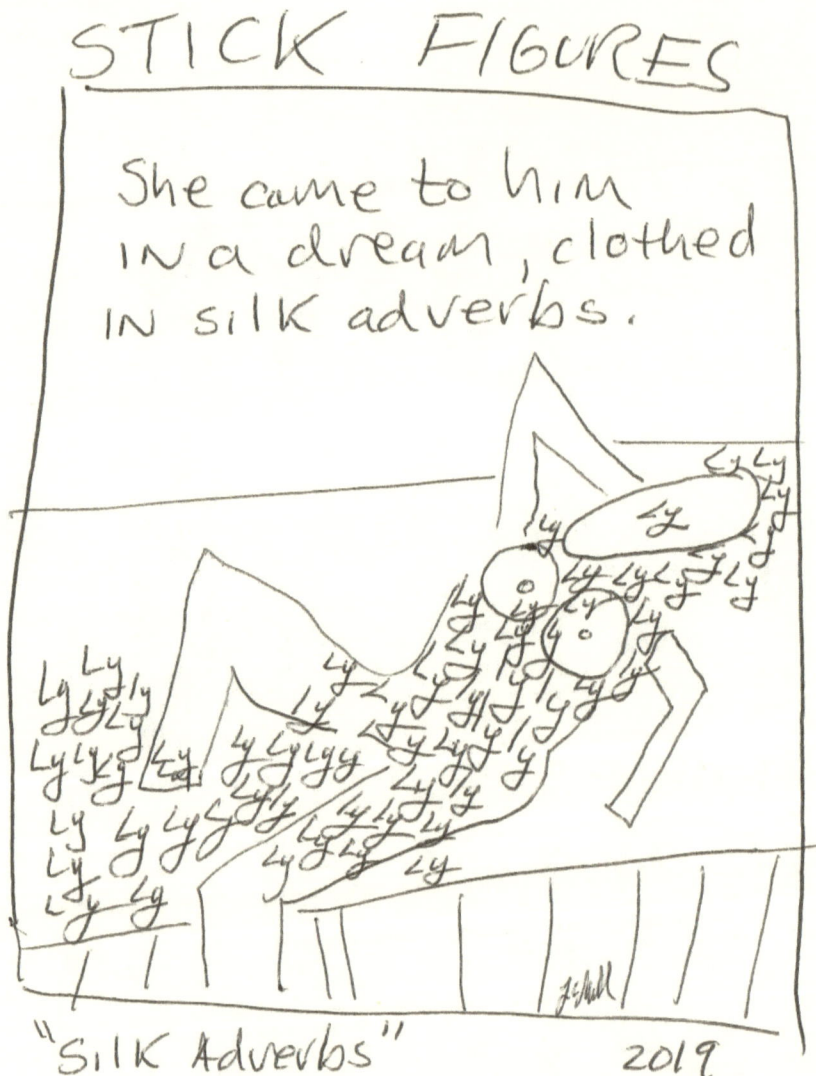

STICK FIGURES

You know you've adapted to life in West Virginia...

"eee-hah!" 4x4

...when you have an overwhelming urge to buy a truck. A BIG truck.

"Resistance is Futile"

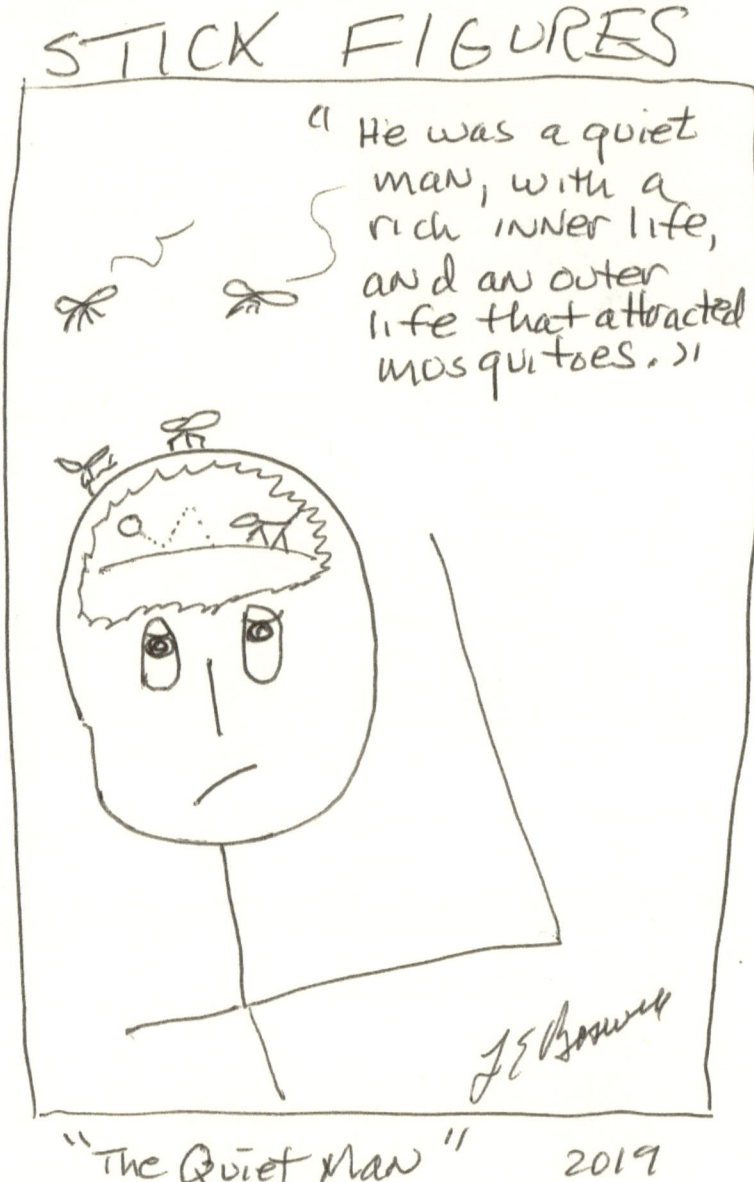

STICK FIGURES

The secret to a happy life is to see with your ears, listen with your eyes, and keep your hands the hell off my stuff.

"Life's Secret"

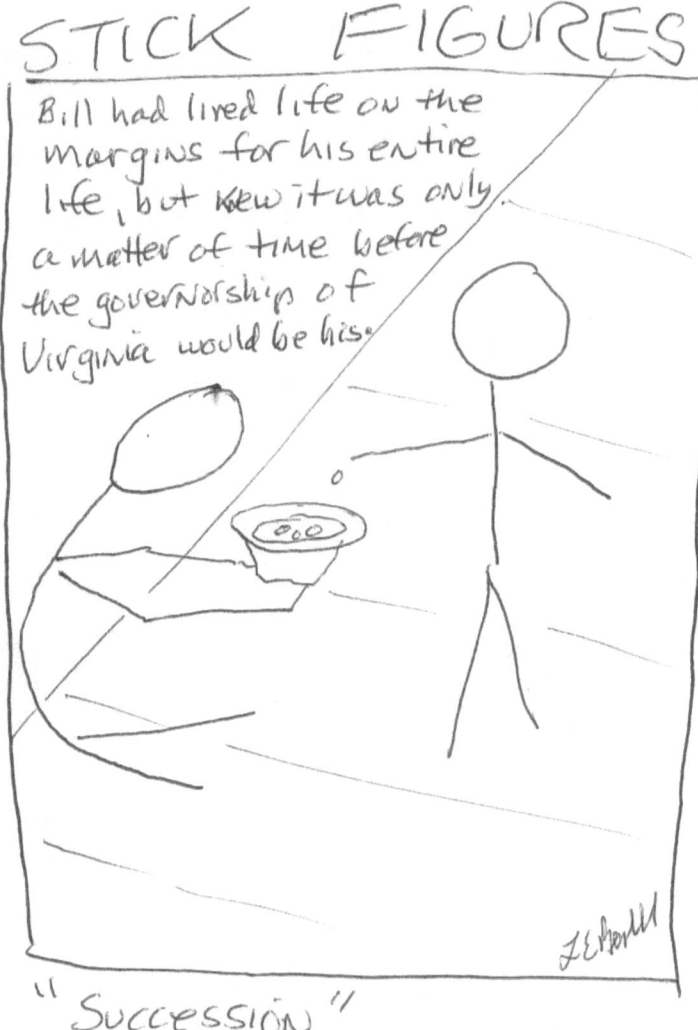

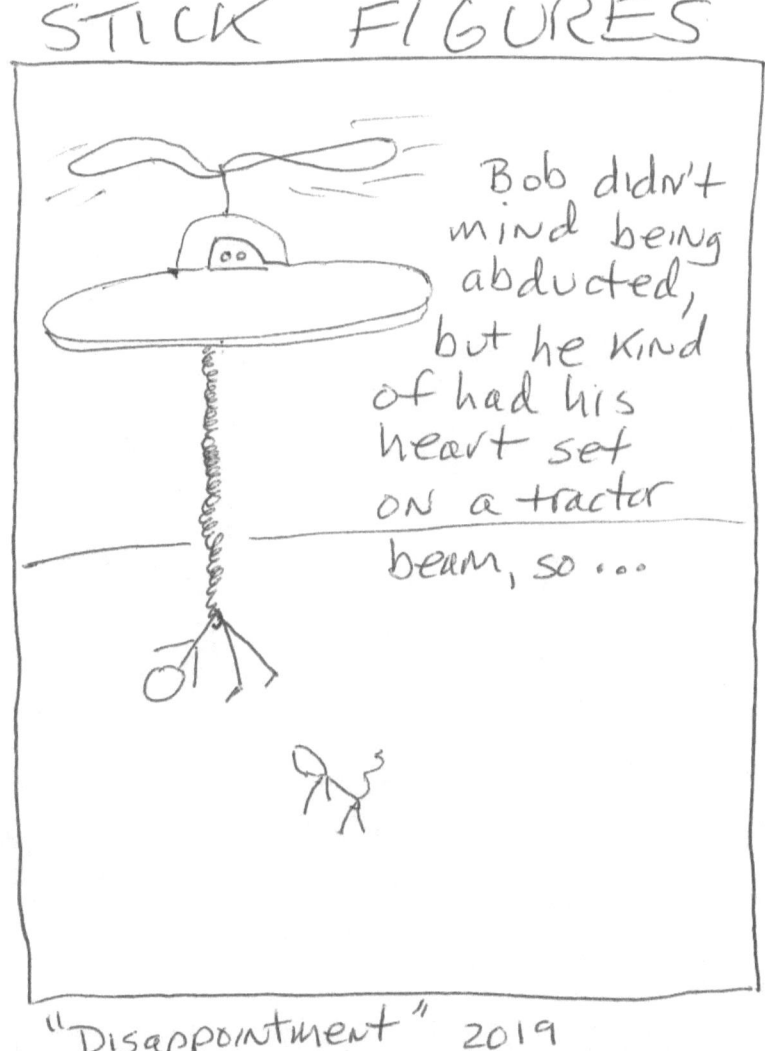

STICK FIGURES

Shadow scores a perfect 10 for his under-the-covers, 3-spin plop down...

"Shadow with a Twist"

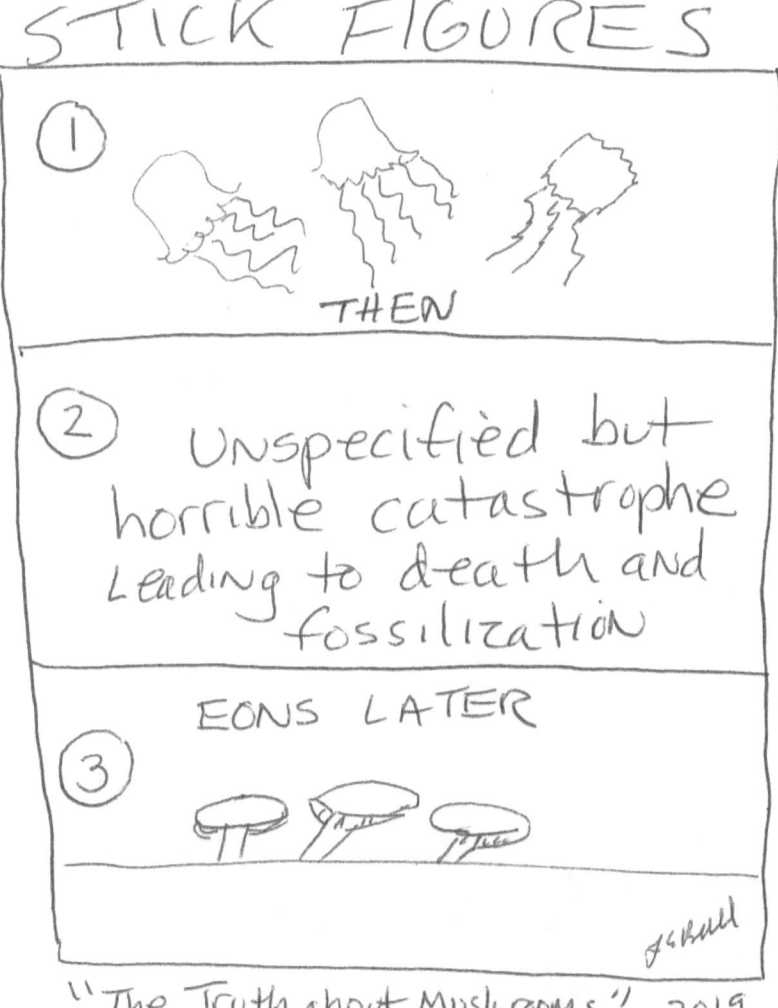

STICK FIGURES

They called him a daydreamer, but in truth, he was not just "far away," he was long gone, riding the eddies of time — past, present, future, and sidetimes. The world would never be his, but he had a firm grip on eternity.

JE Boswell

"The Time Traveler" 2019

Part Three
Word Play, Stick Play

Sometimes Boswell incorporates words into his drawings, and sometimes—imp that he is—he lets the art speak for itself. Puns, idioms, and outrageous wordplay are all part of his oeuvre.

The twenty-one drawings that follow are just that. Enjoy!

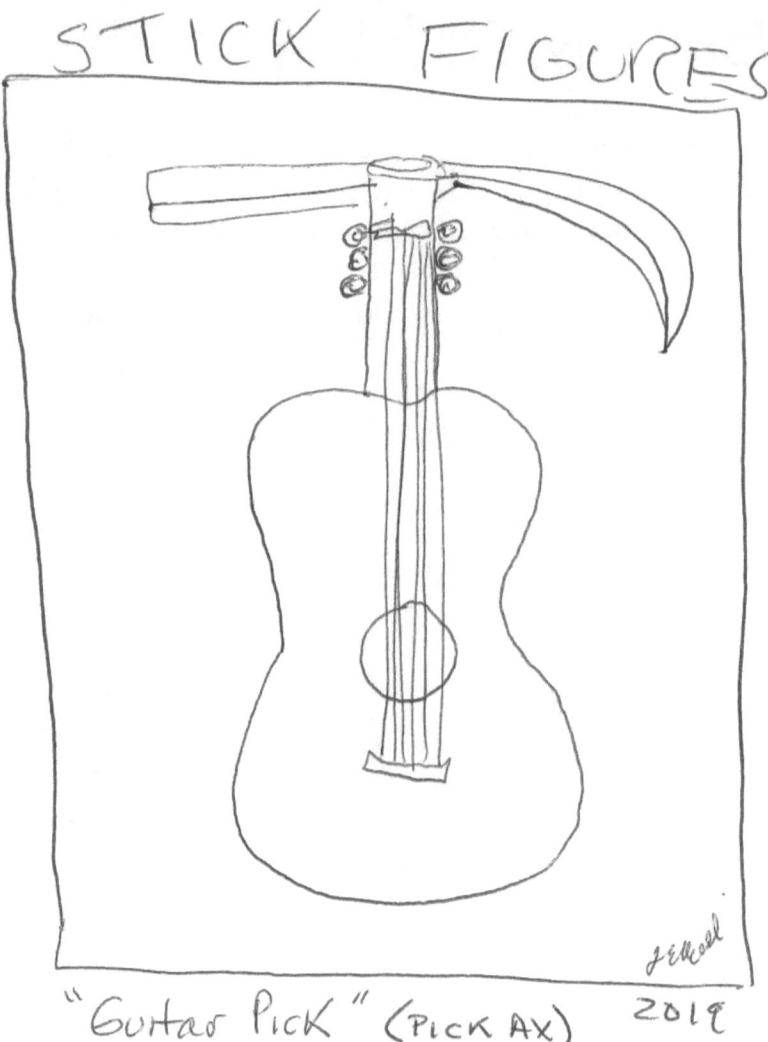

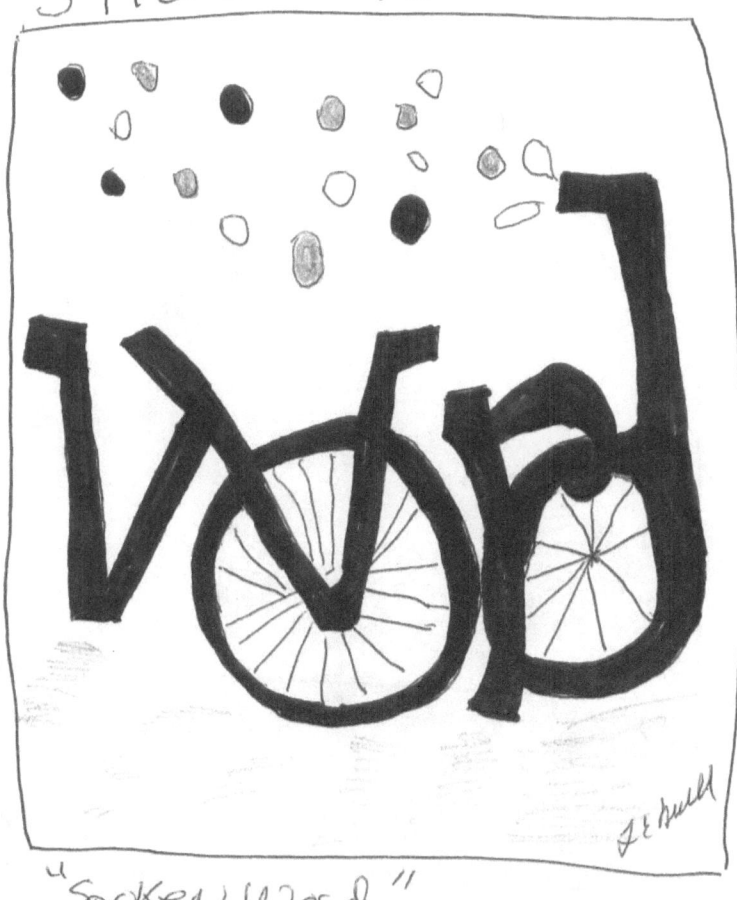

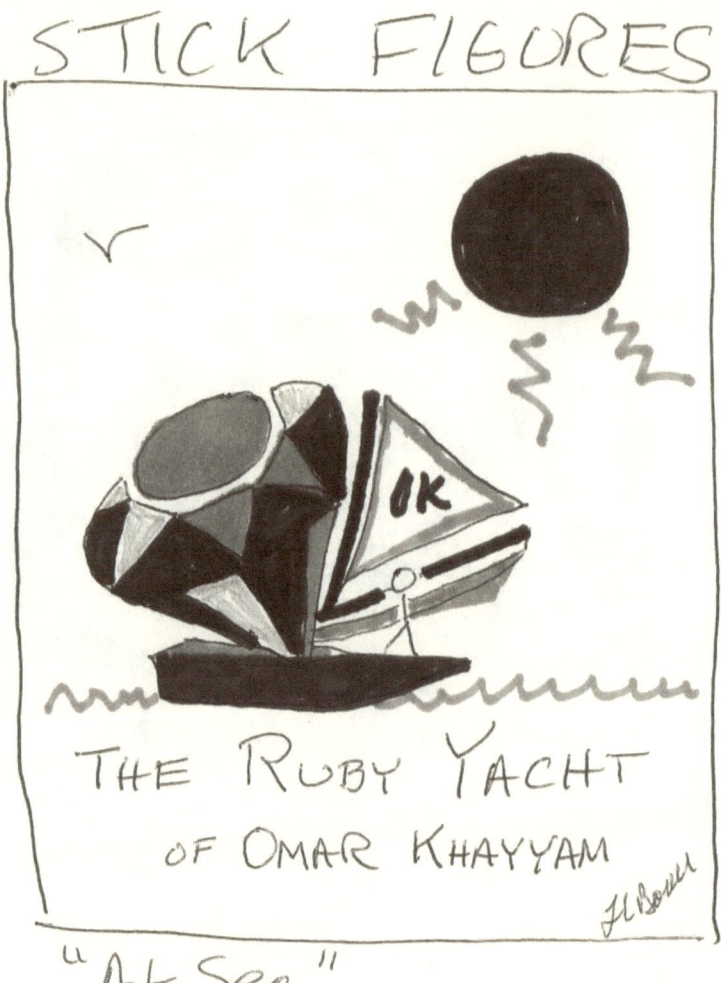

"At Sea"

STATUE OF LIMITATIONS

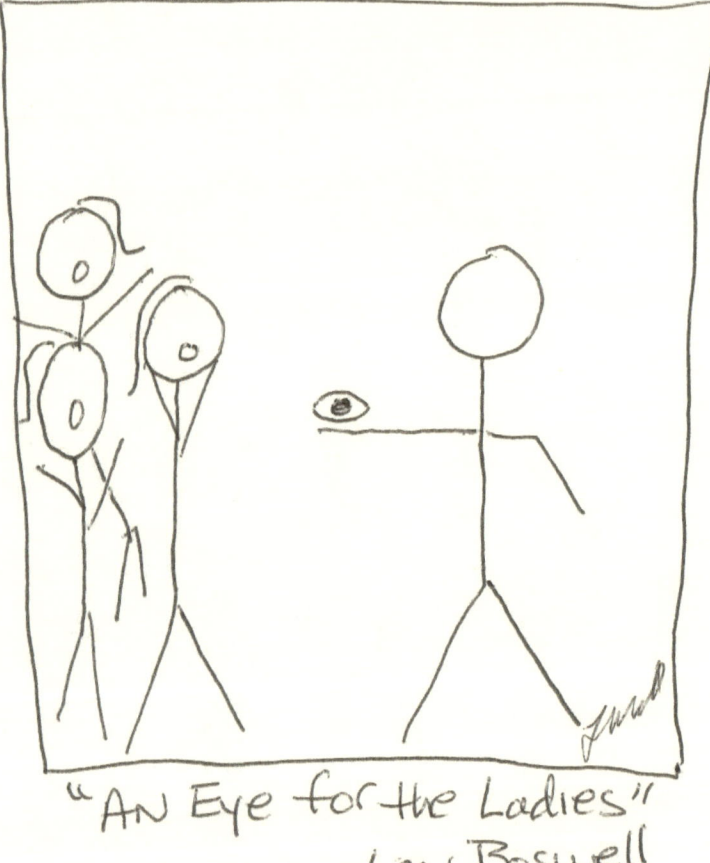

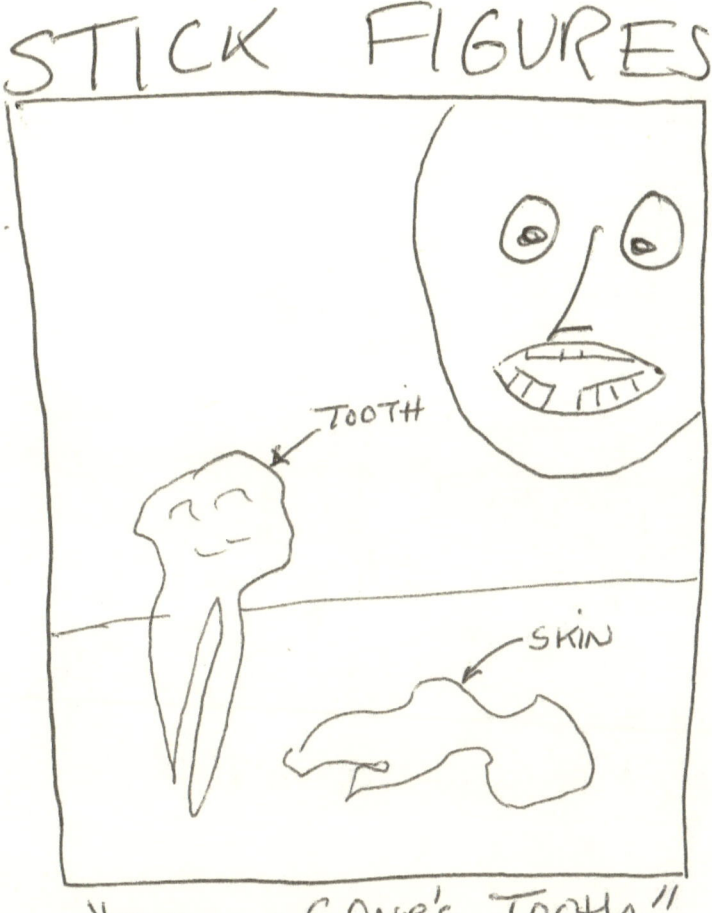

"Skin of One's Tooth"
Len Boswell
Ink, 8'x10', 2018

STICK FIGURES

STICK FIGURES

> **STICK FIGURES**
>
> He loved his new car, but it came at a price...
>
> *—K Hull*

Idiom Attic #1

Idiom Attic #3

STICK FIGURES

STICK FIGURES

a blessing

Idiom Attic #4

STICK FIGURES

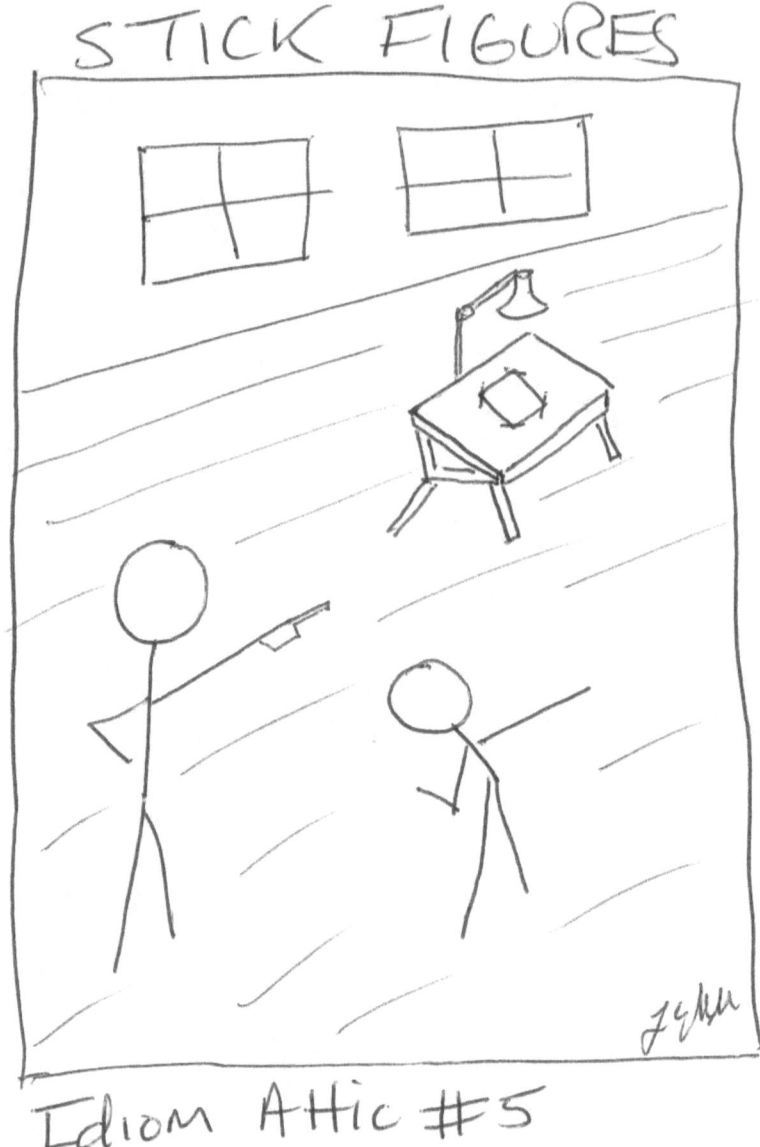

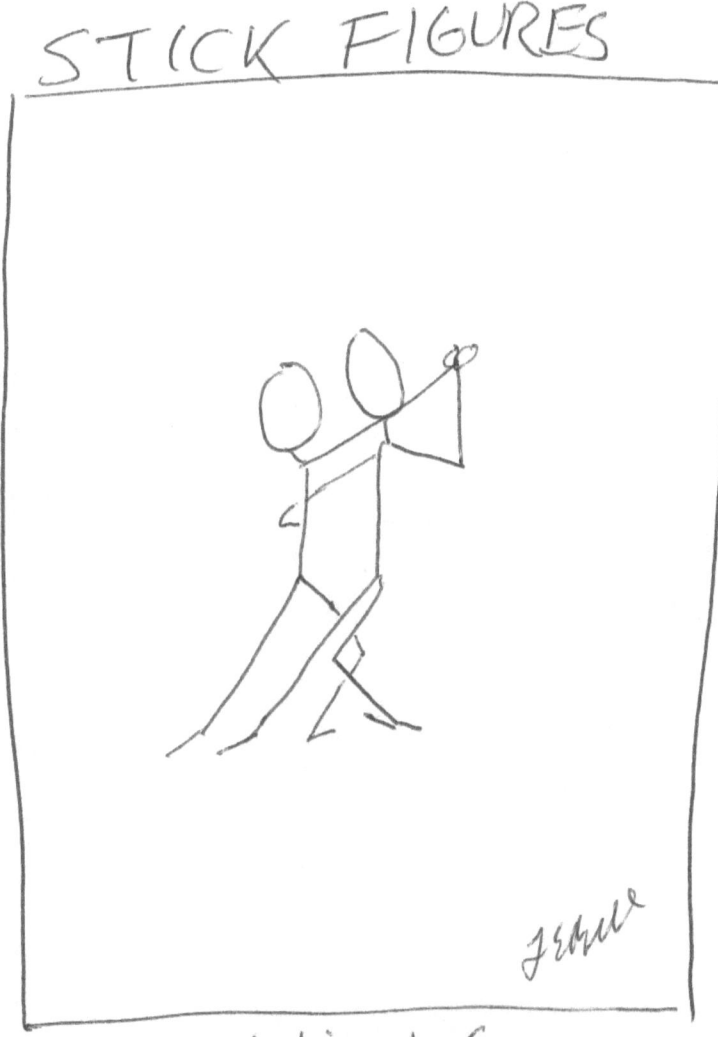

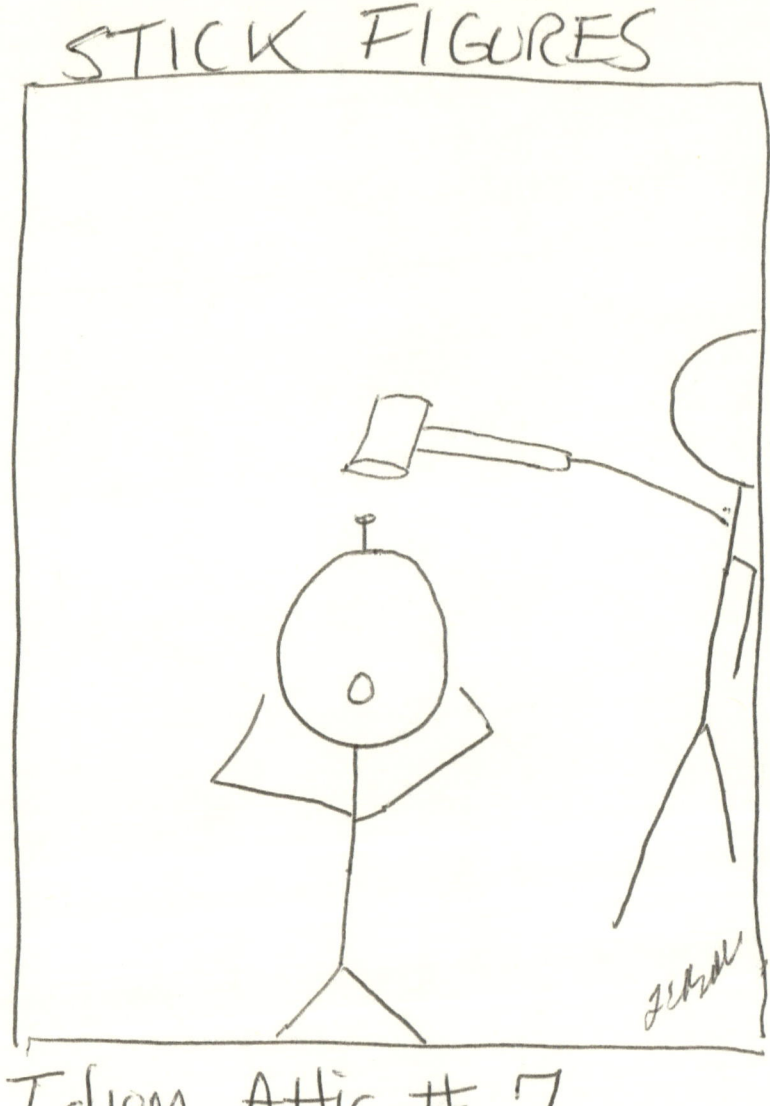

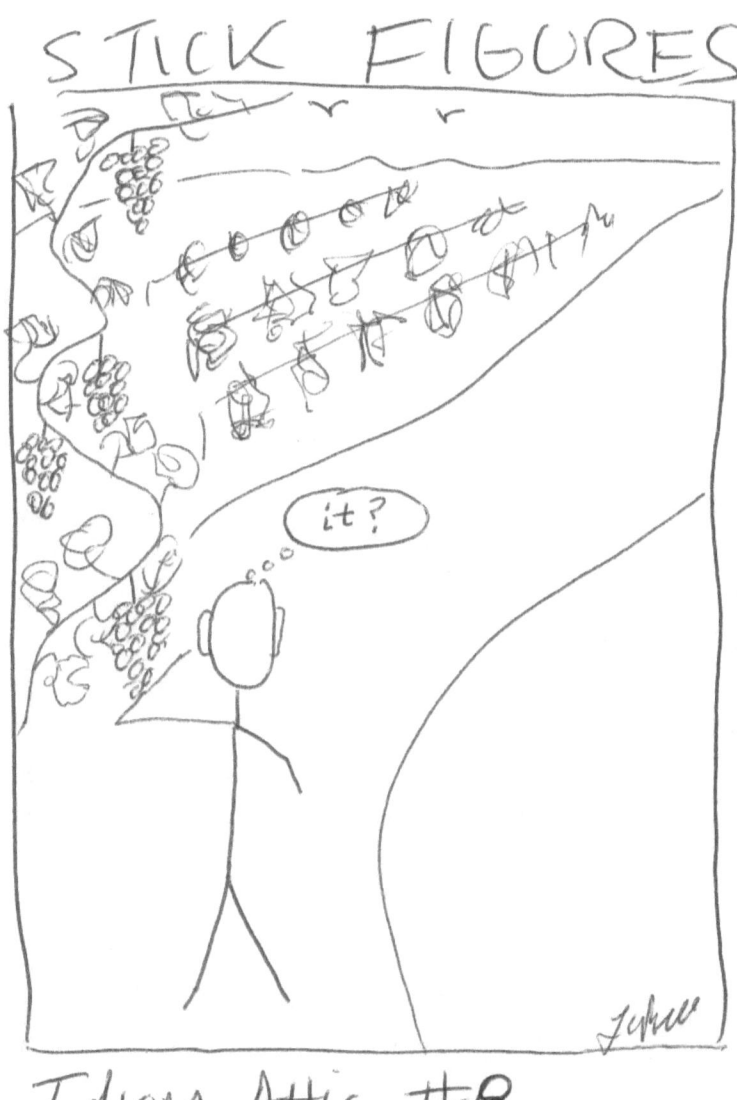

Idiom Attic #8

Idiom Attic #9

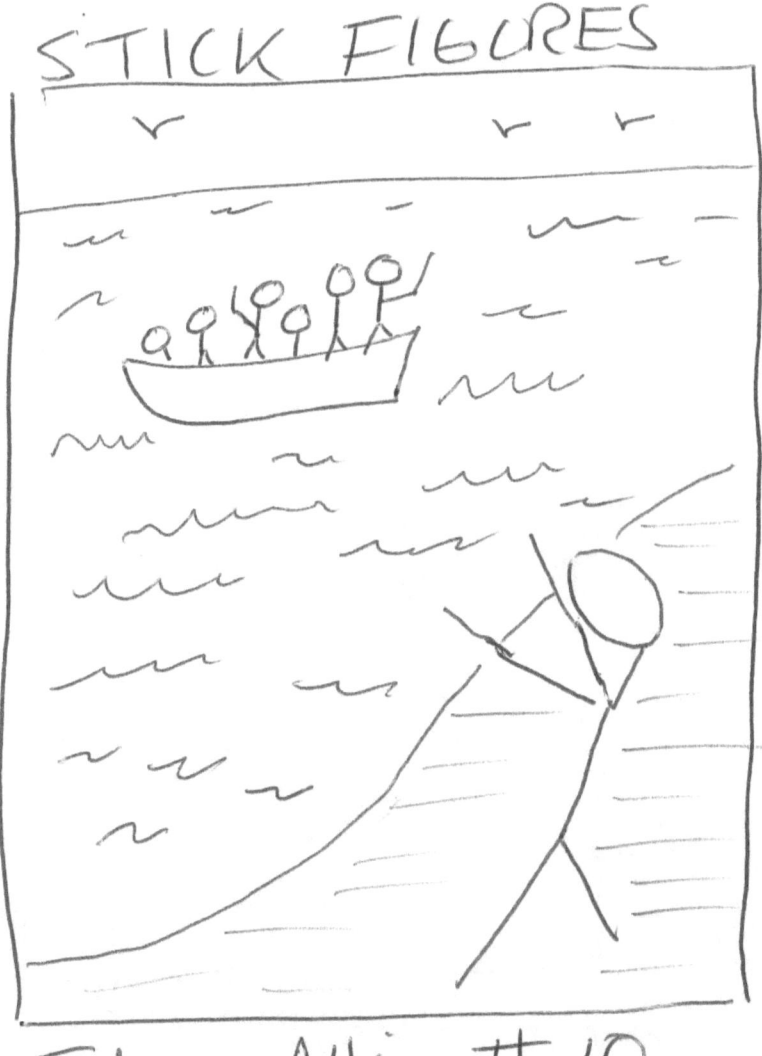

Idiom Attic #12

STICK FIGURES

Life can be funny all together, even when it's not altogether funny.

"Life" J E Howell 2019

Part Four
Boswell Re-creates the Masters

A critic who shall remain nameless once challenged Boswell to re-create master works, hoping to unfrock him as an artist. However, as you will see in the drawings that follow, Boswell was more than up for the challenge, capturing the essence and style of artists from every era in nineteen unforgettable drawings.

LEN RE-CREATES THE MASTERS

Portrait of a Polish Woman
— Amedeo Modigliani

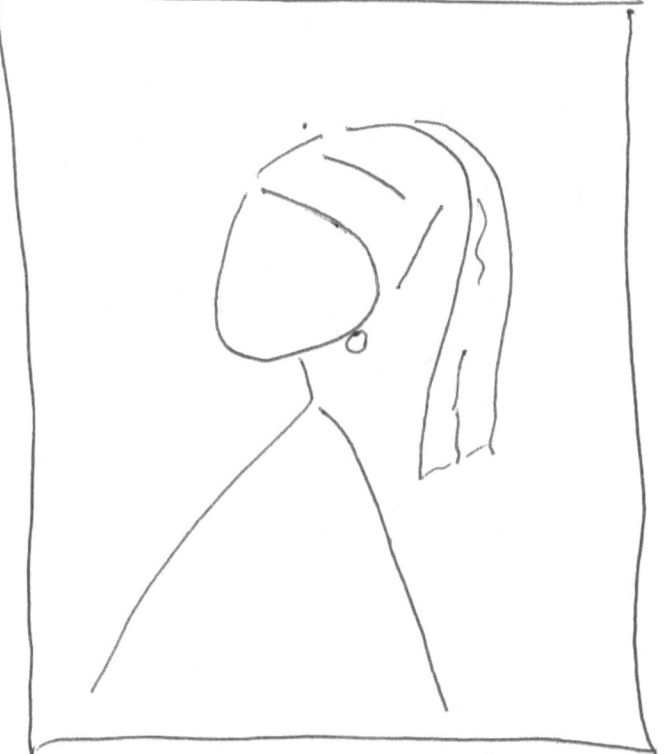

LEN RE-CREATES THE MASTERS

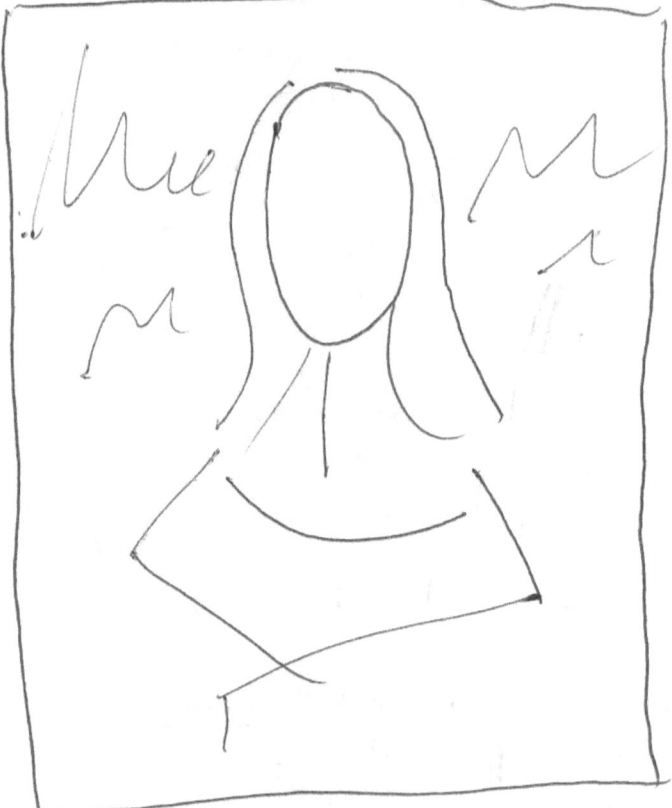

MONA LISA
—Leonardo DaVinci

STICK FIGURES

Portrait of a Young Girl — Joan Miró

STICK FIGURES

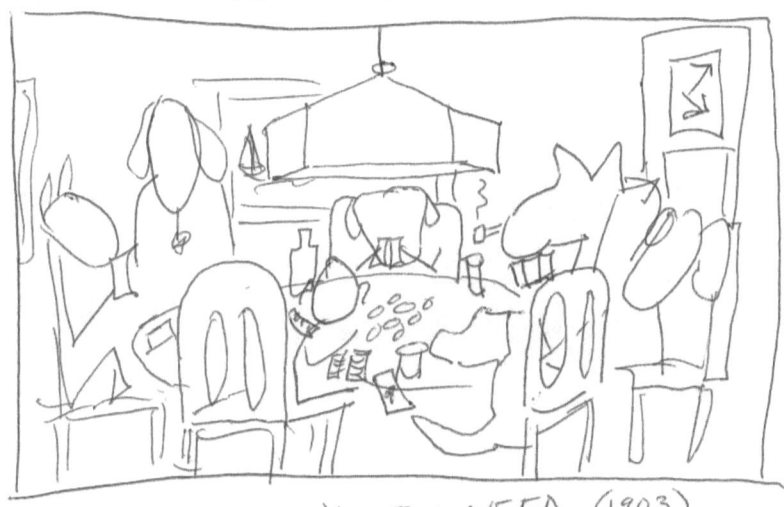

LEN RE-CREATES THE MASTERS

A FRIEND IN NEED (1903)
— CASSIUS MARCELLUS COOLIDGE

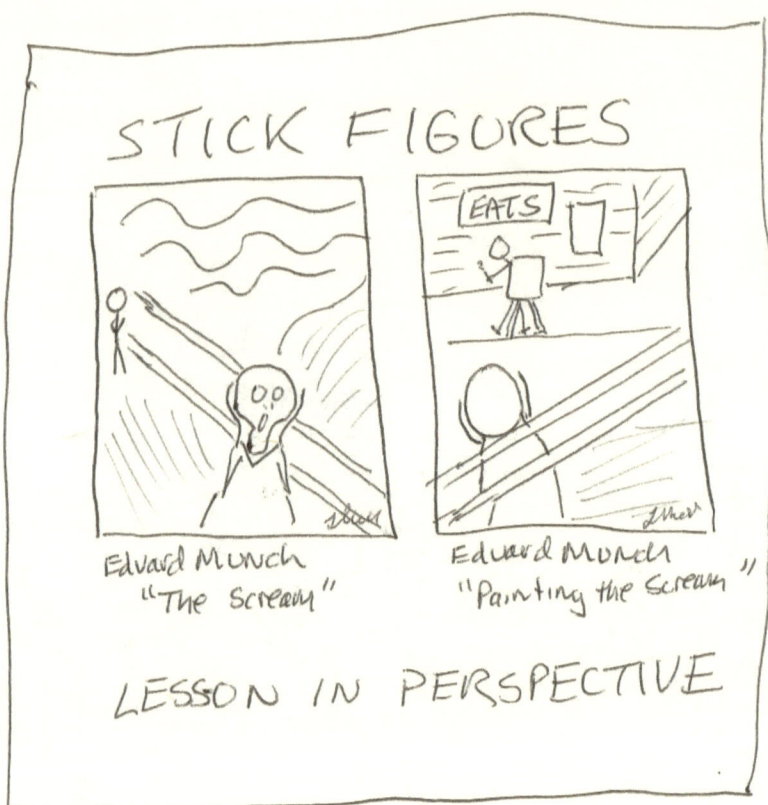

STICK FIGURES

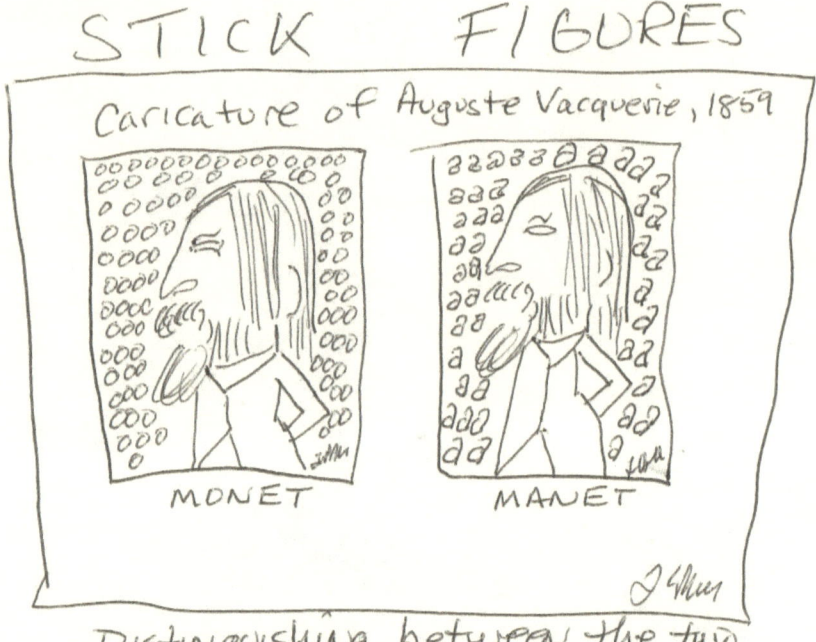

Distinguishing between the two requires a close examination of the details

— From Art Lessons, Third Edition

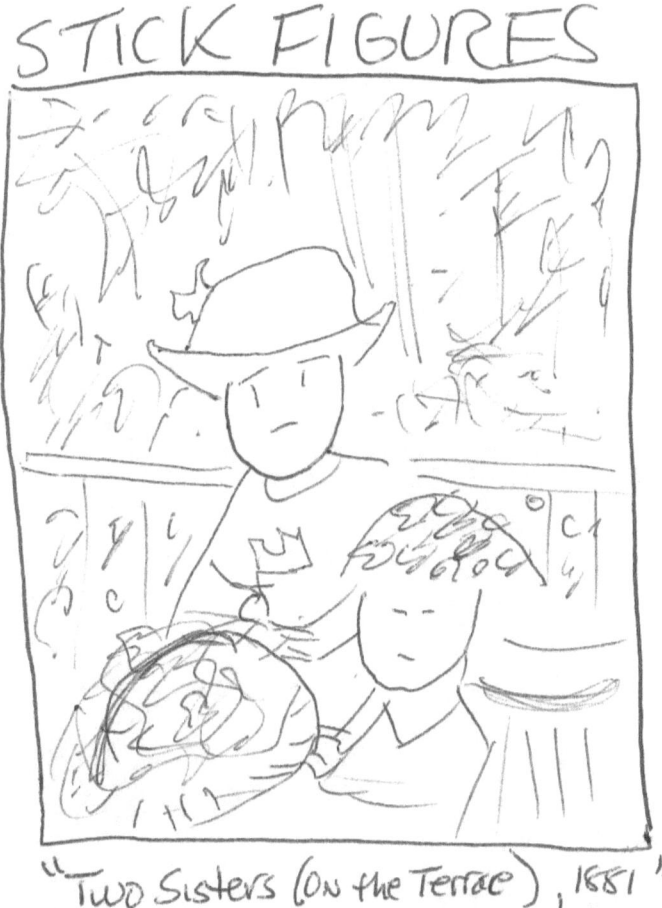

"Two Sisters (On the Terrace), 1881"
Pierre-Auguste Renoir

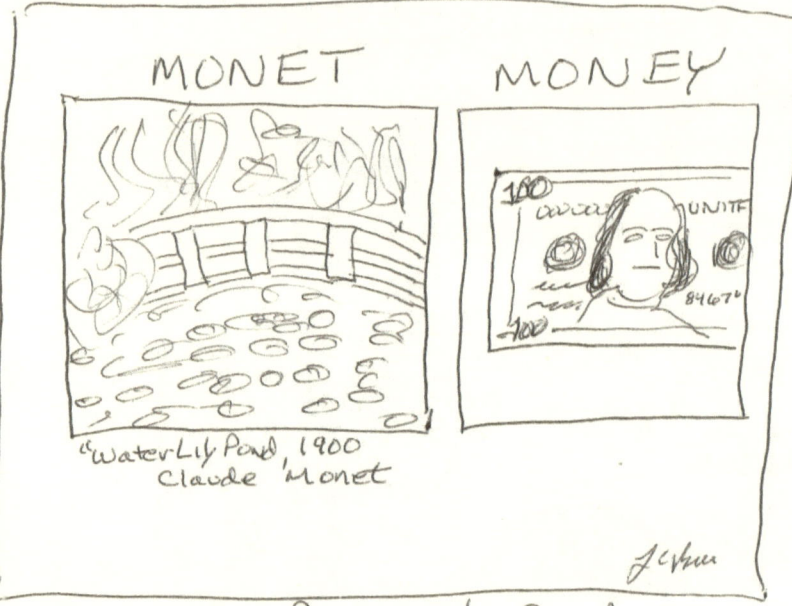

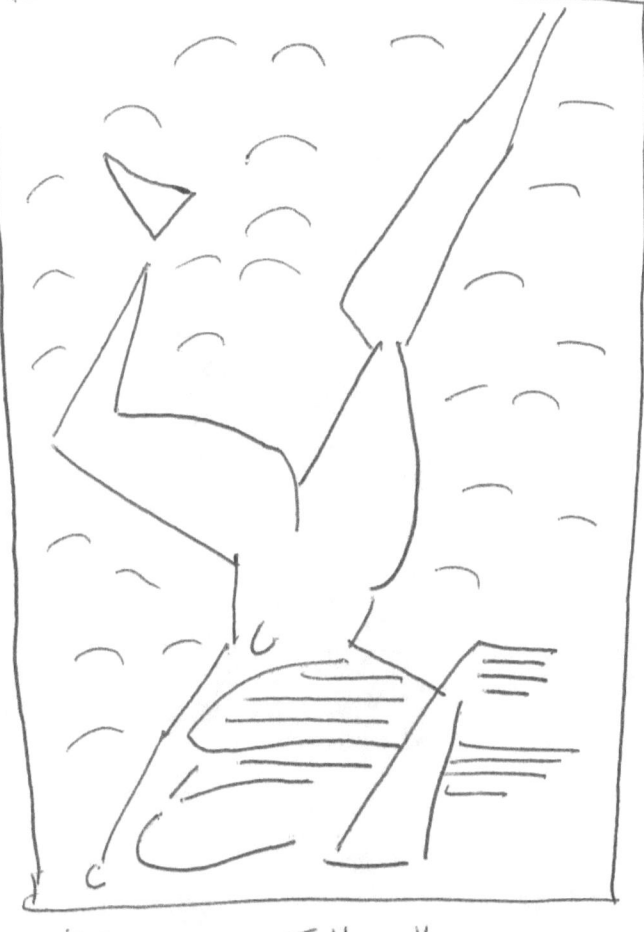

"Her New Tattoo"
Oil, 24x30, 1990
Leigh Slagden

STICK FIGURES

LEN RE-CREATES THE MASTERS

Personage and Stars, 1950
Joan Miró "Miró, Miró on the Wall"

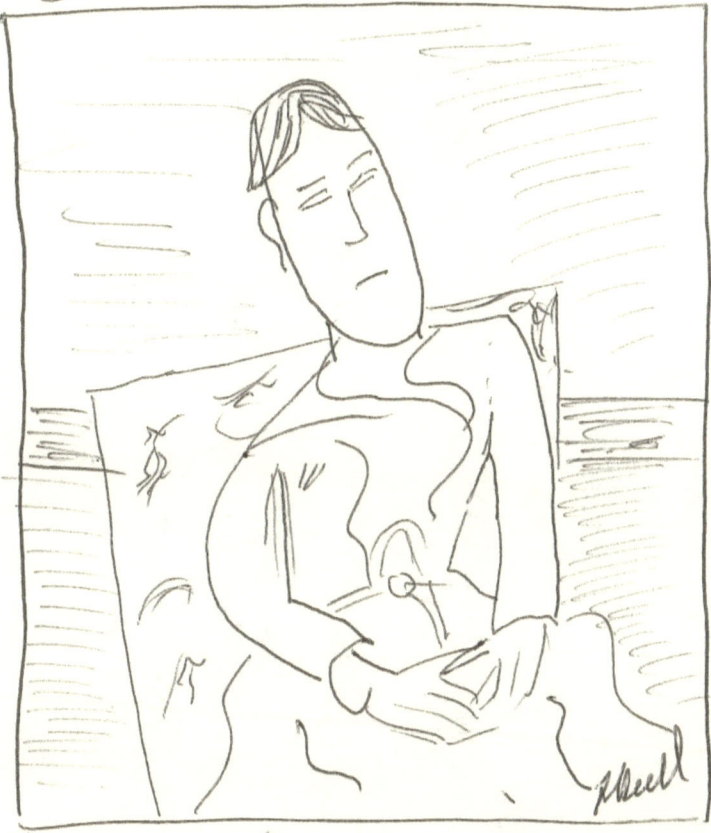

"Madame Cézanne in a Yellow Chair"
Paul Cézanne, 1888-90

"Paris Street; Rainy Day, 1877"
Gustave Caillebotte

STICK FIGURES

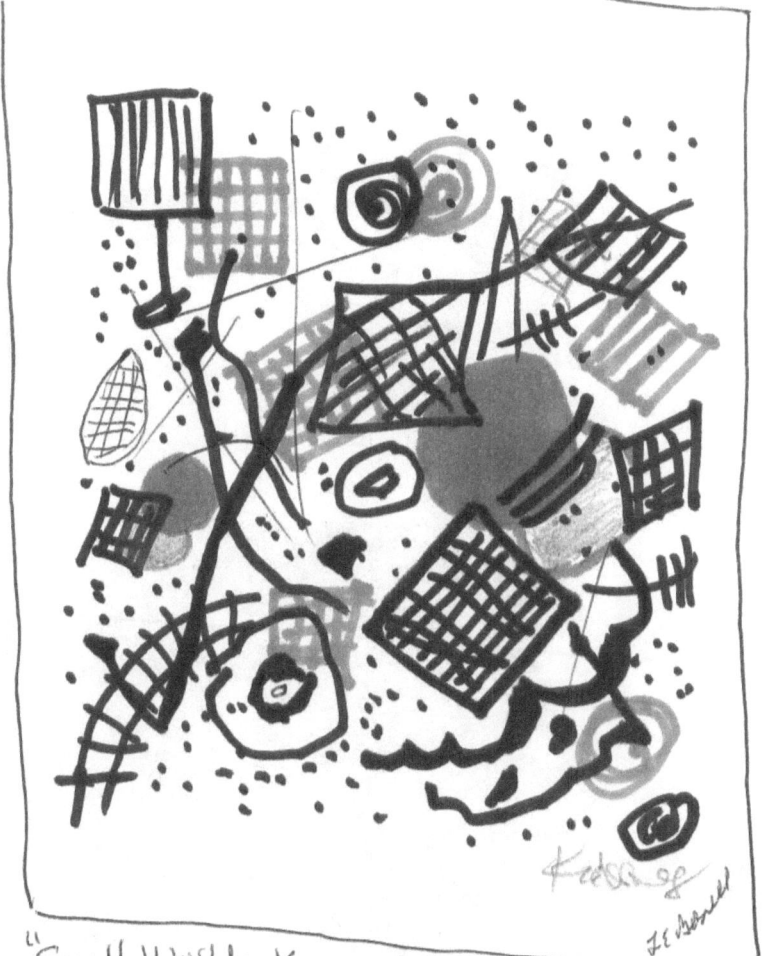

"Small Worlds V, plate five, from Kleine Welten, 1922"
Vasily Kandinsky

STICK FIGURES

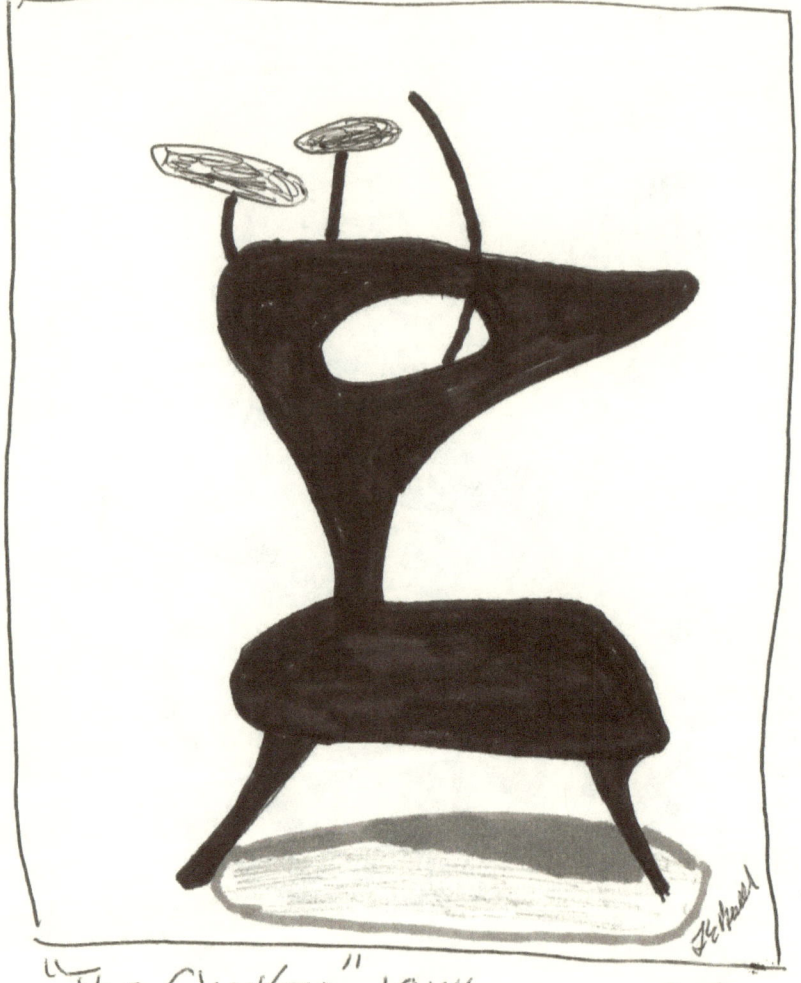

"The Chicken" 1944 Alexander Calder

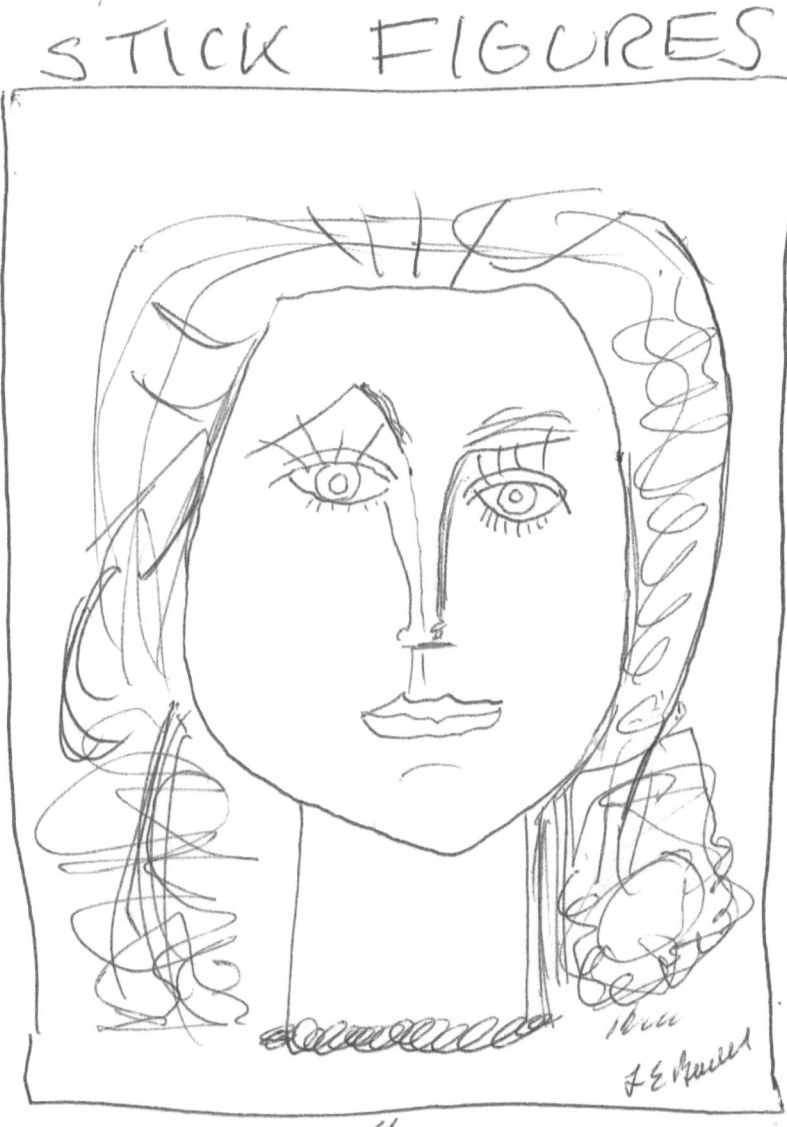

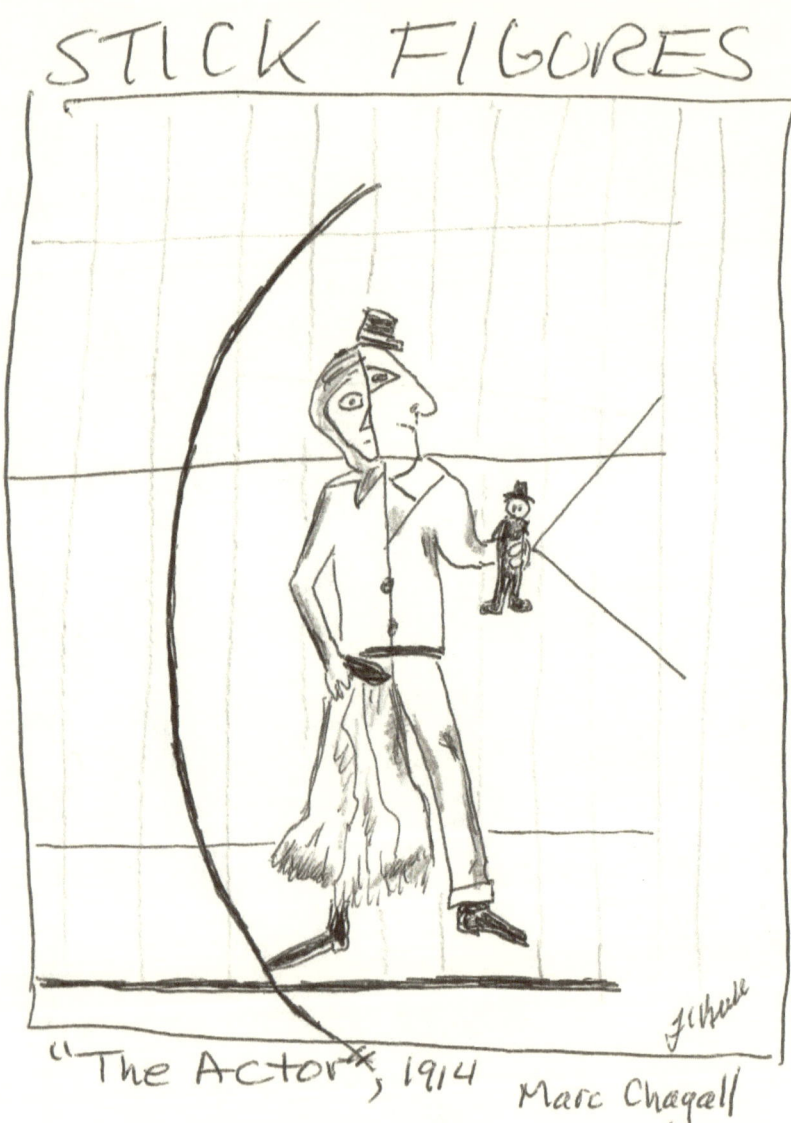

Part Five
Original Art

Boswell's experiment re-creating the masters led him inexorably to creating his own original works, drawings he hoped could stand alone alongside those same masters. As you will see, some of the drawings are derivative of famous artists, while still others are wholly original.

Pay close attention to the "Santa Series," which starts with an attempt to re-create an original Thomas Nast painting and then proceeds to reduce it to its essence in just four steps. Very stickly. There is much to love here. Fifty-four drawings in all. Take your time.

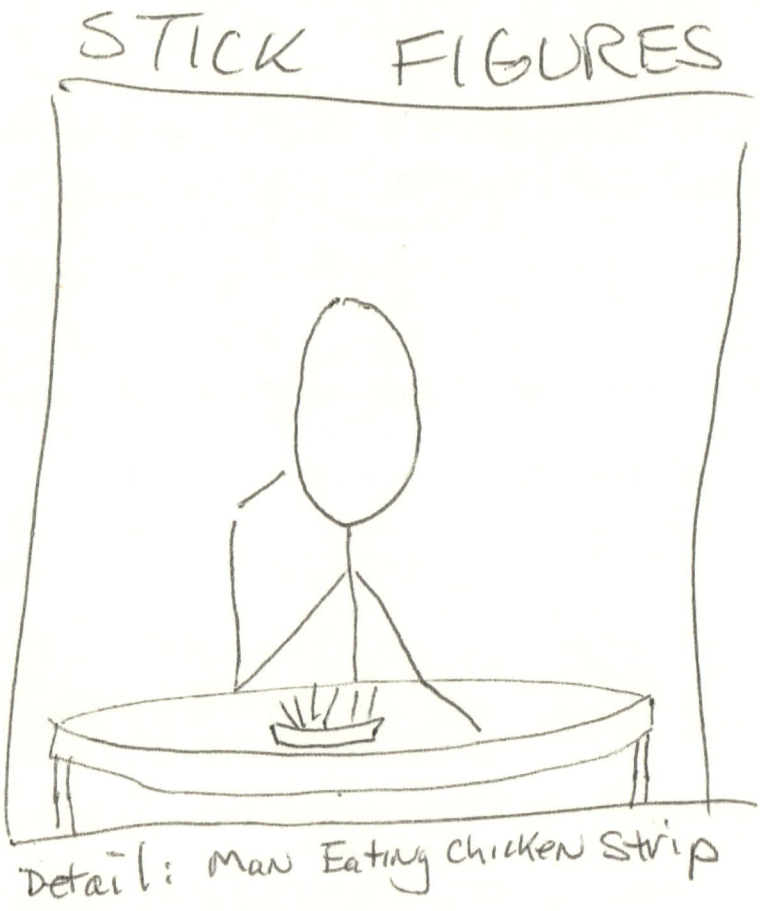

"Still Life with Kindle and Eyeballs"

Len Boswell

Ink, 8ft x 10ft, 2018

"Nude with Knee Brace and Empty Bowl"
Len Boswell

Ink, Infinity X Infinity, 2018

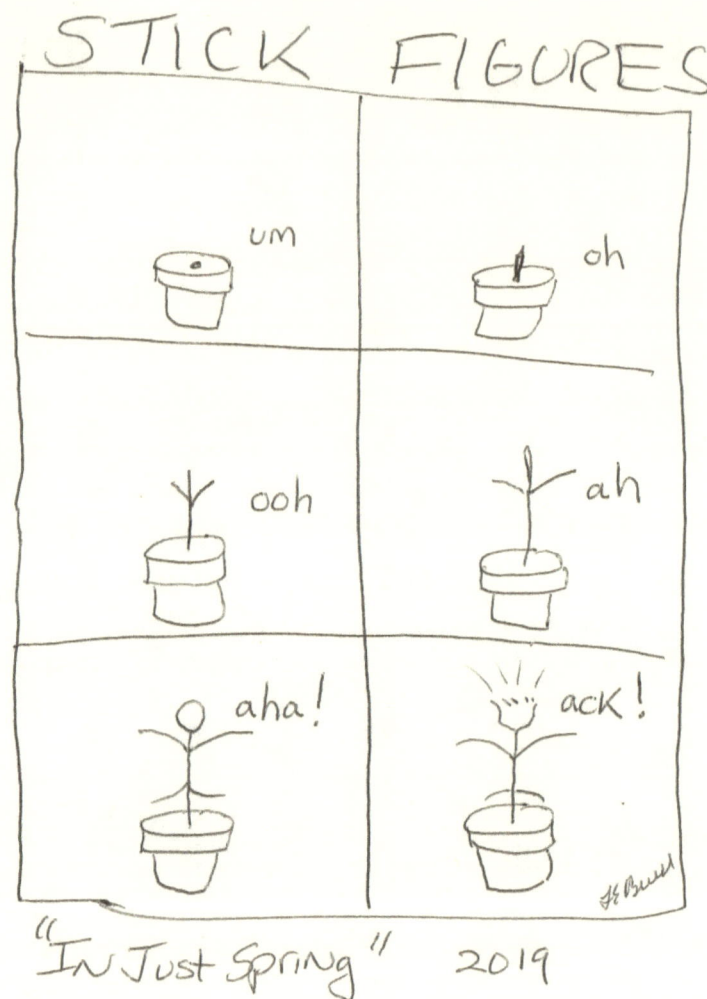

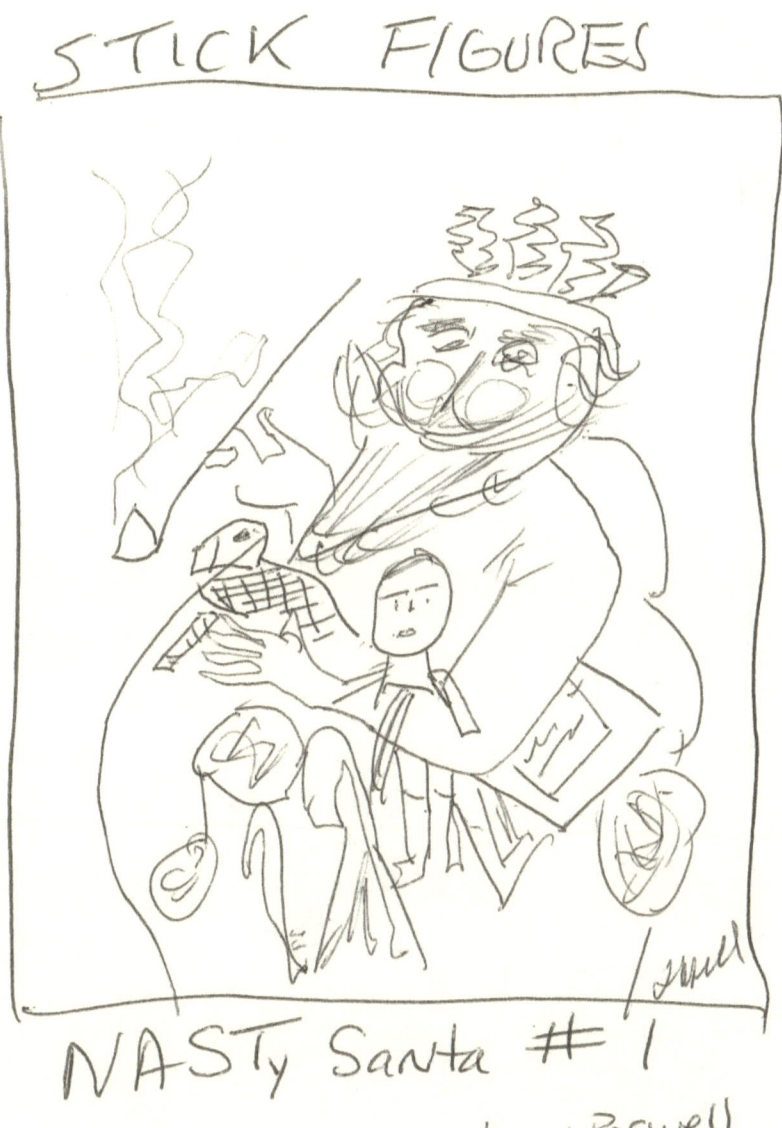

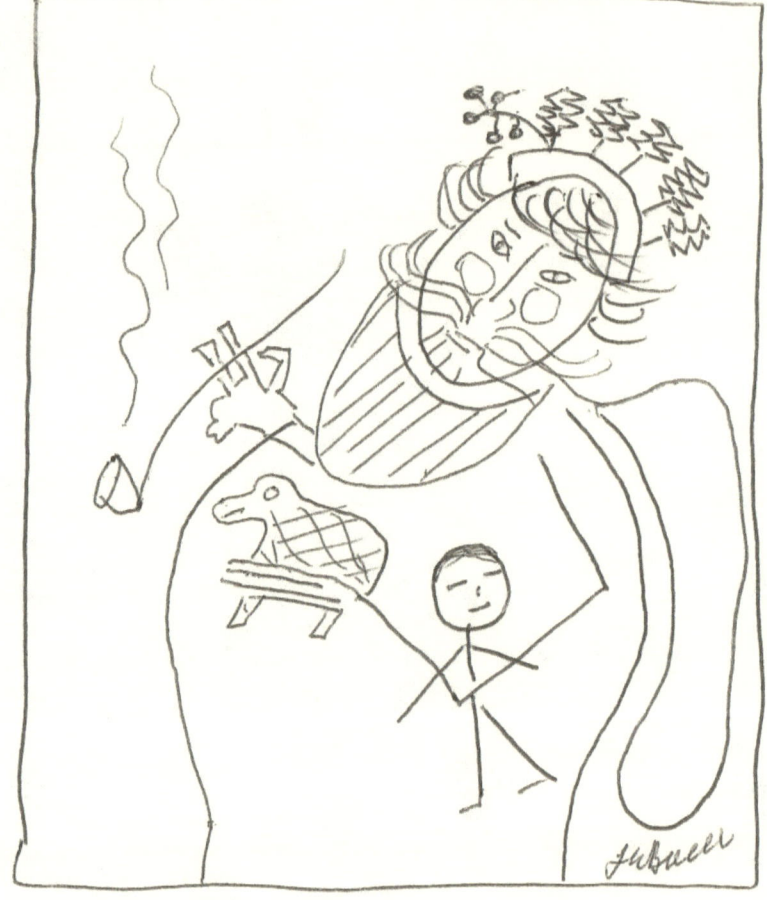

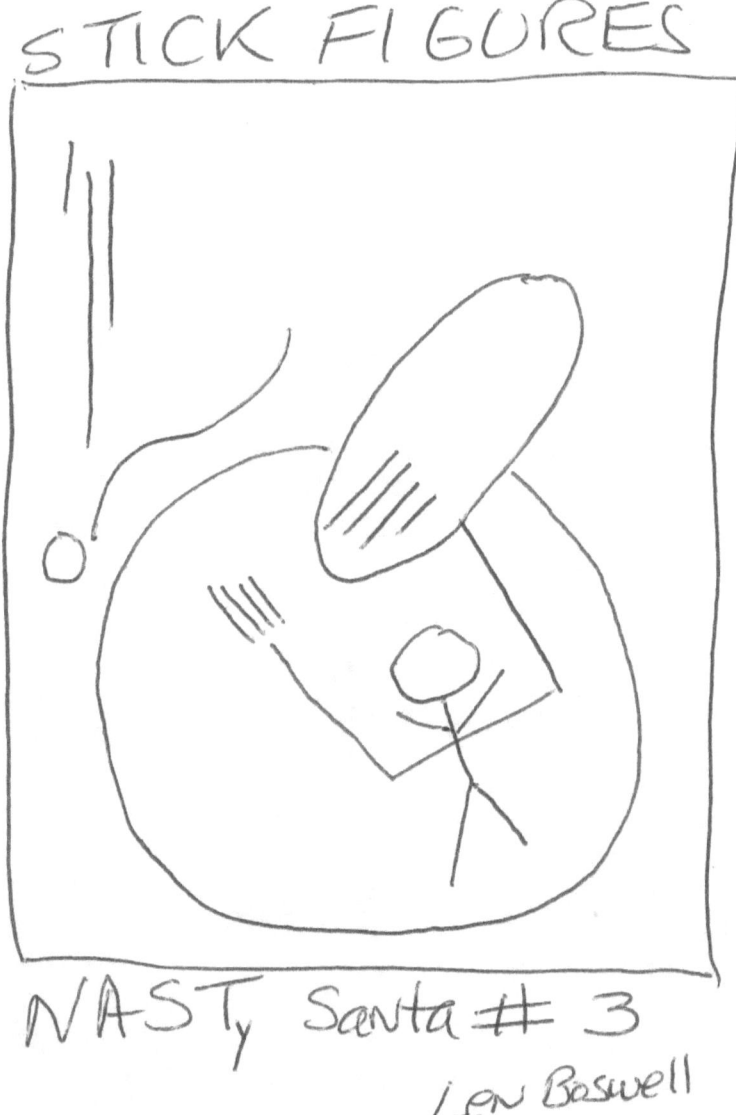

NASTy Santa #4

Len Boswell

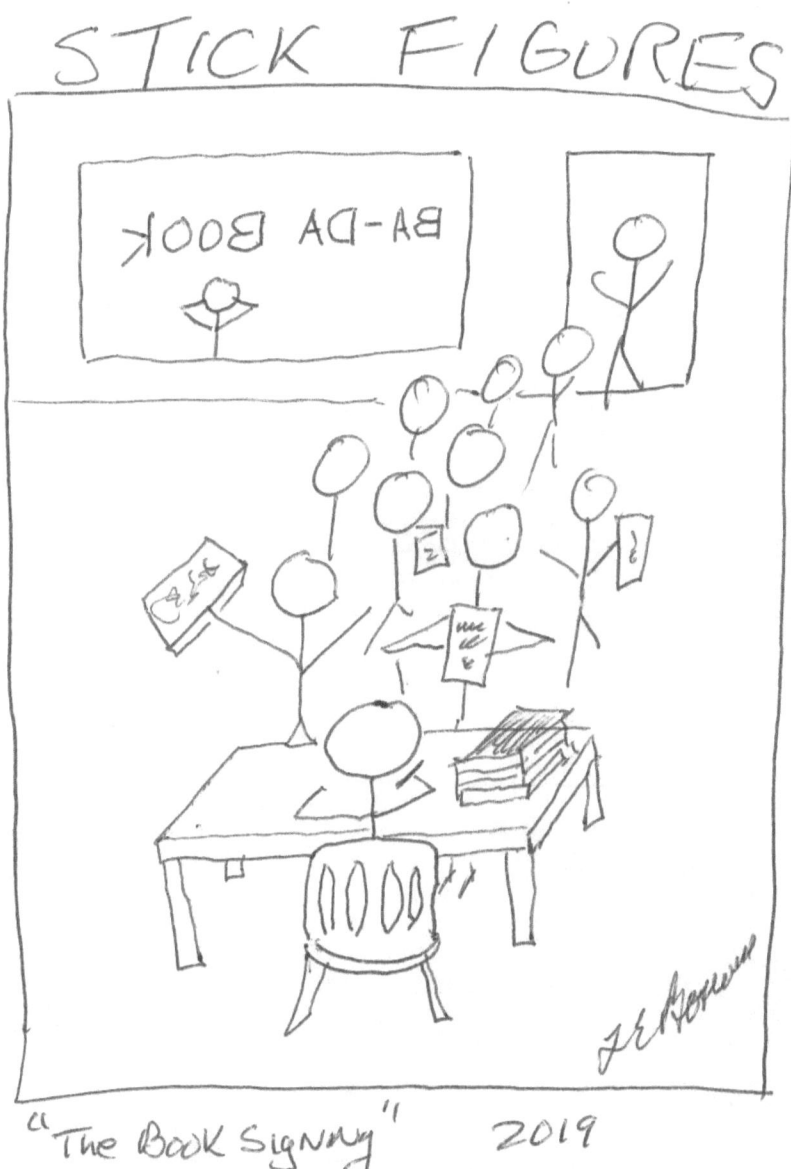

STICK FIGURES

"Fruit of the Month Club"
Ink, 24 x 36, 2018

Len Boswell

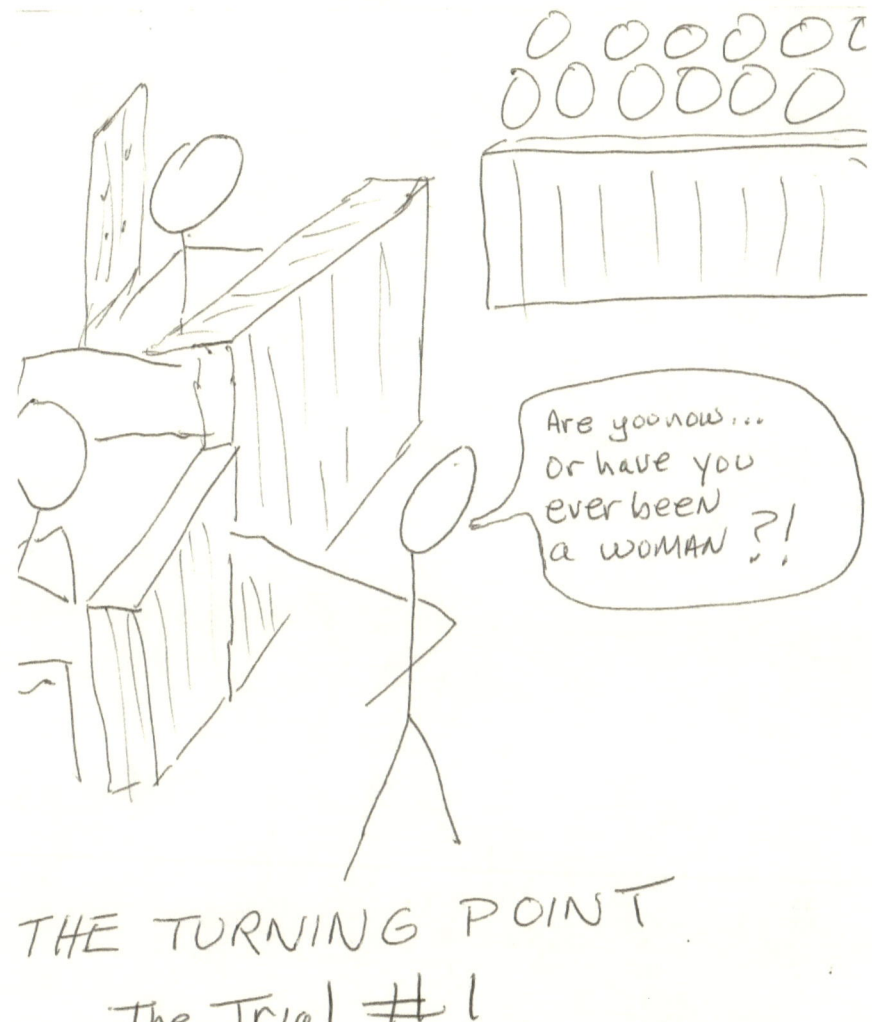

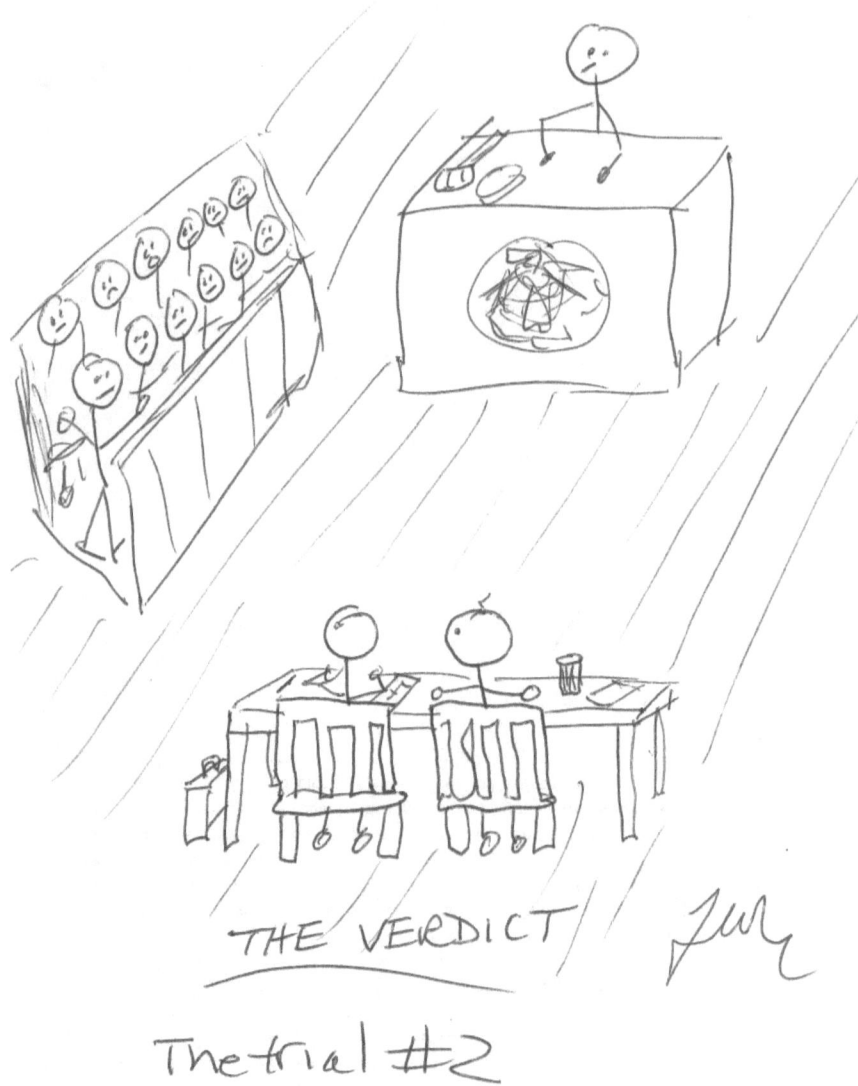

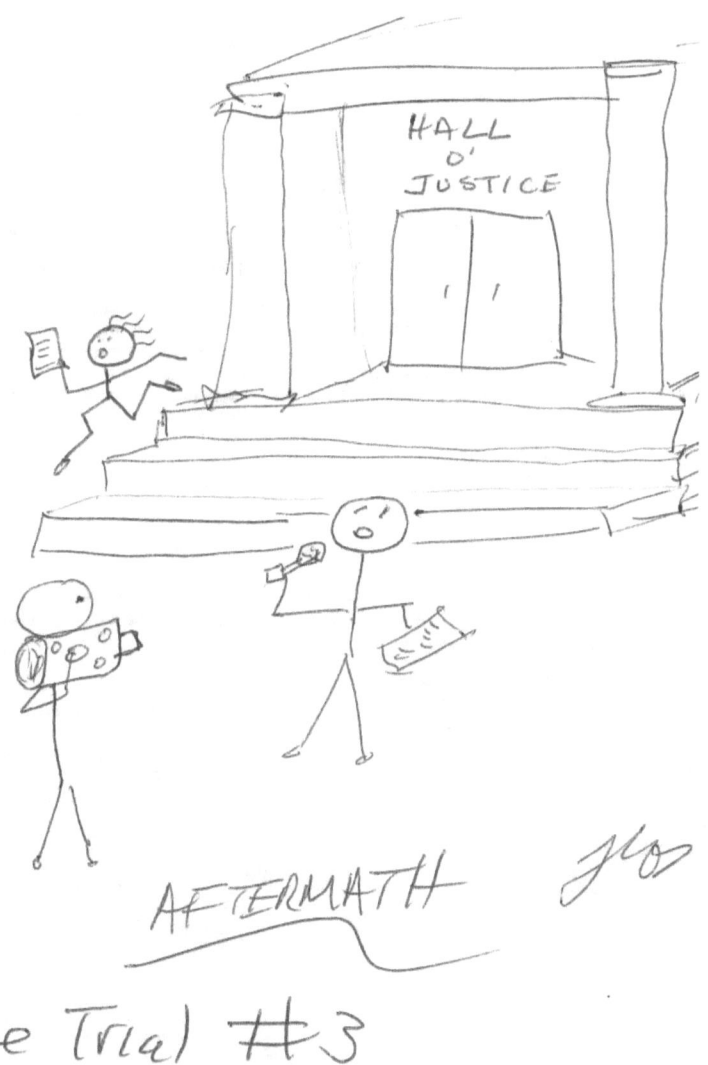

STICK FIGURES

Stick Mobile No. 1
Len Boswell

STICK FIGURES

"Bruegel Dream"
Len Boswell, 2019

STICK FIGURES

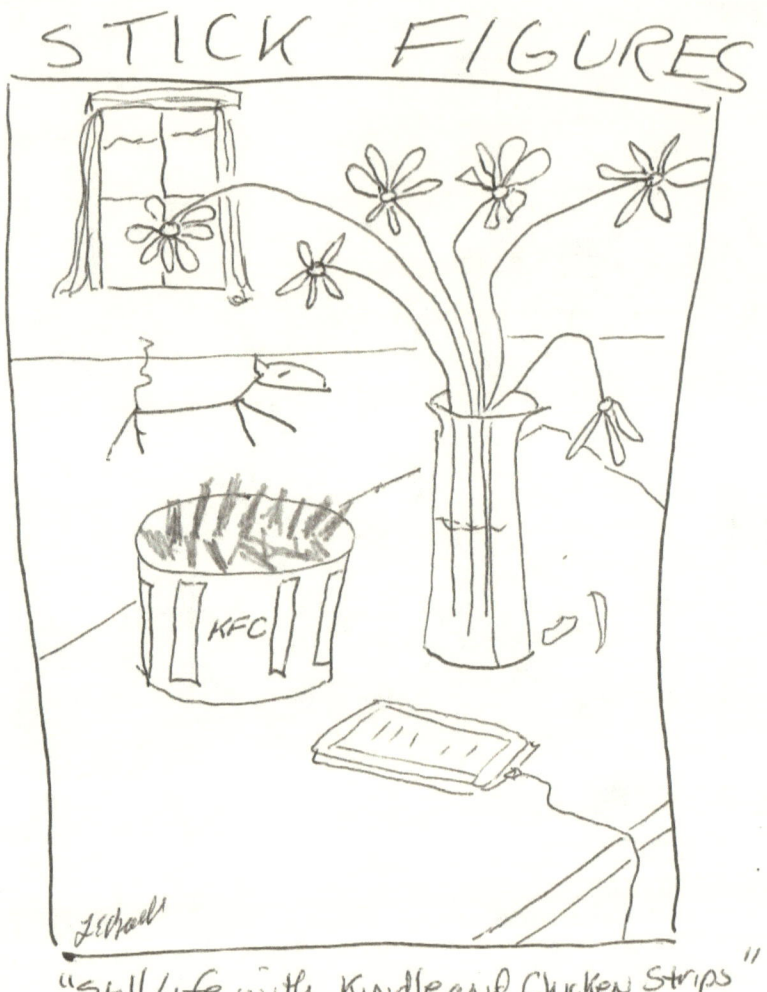

"Still Life with Kindle and Chicken Strips"

STICK FIGURES

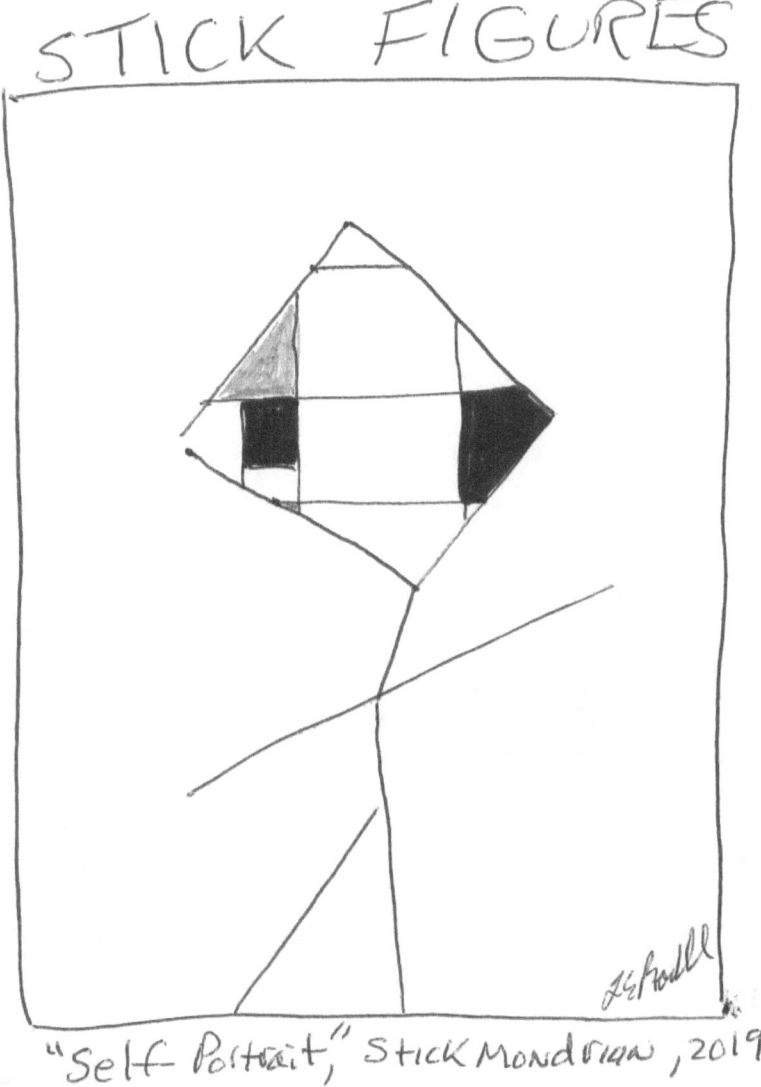

"Self Portrait," Stick Mondrian, 2019

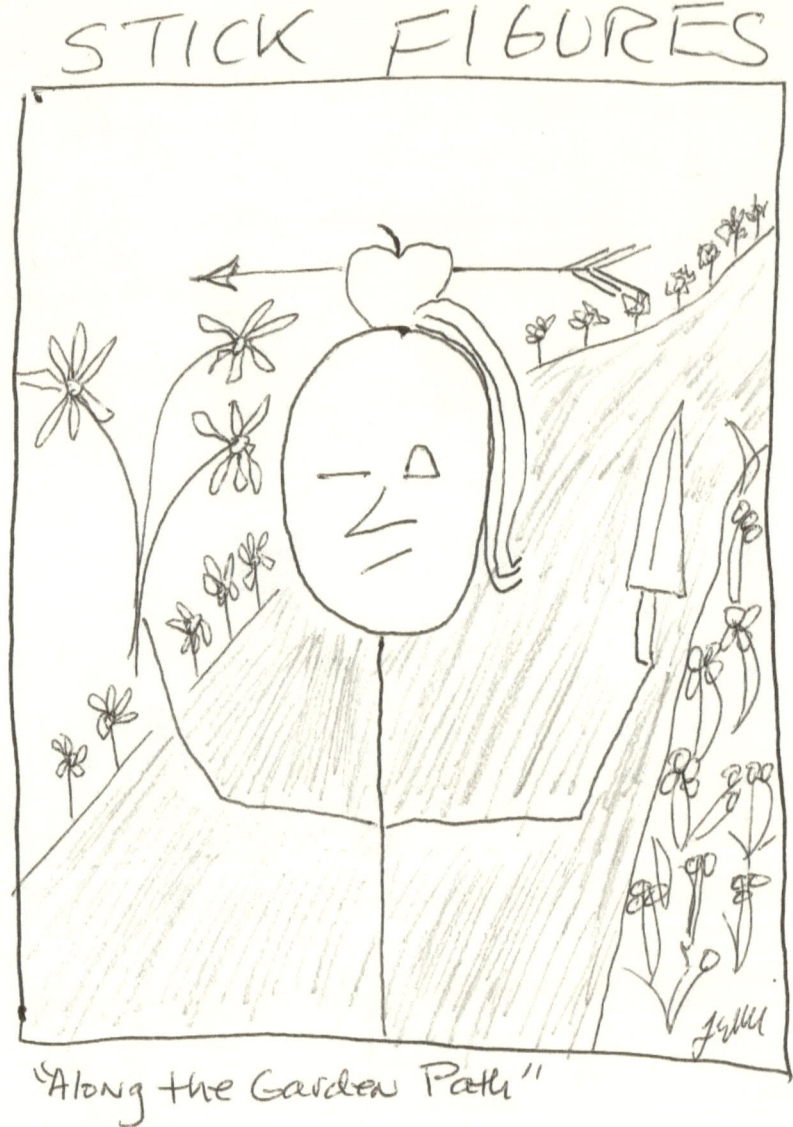

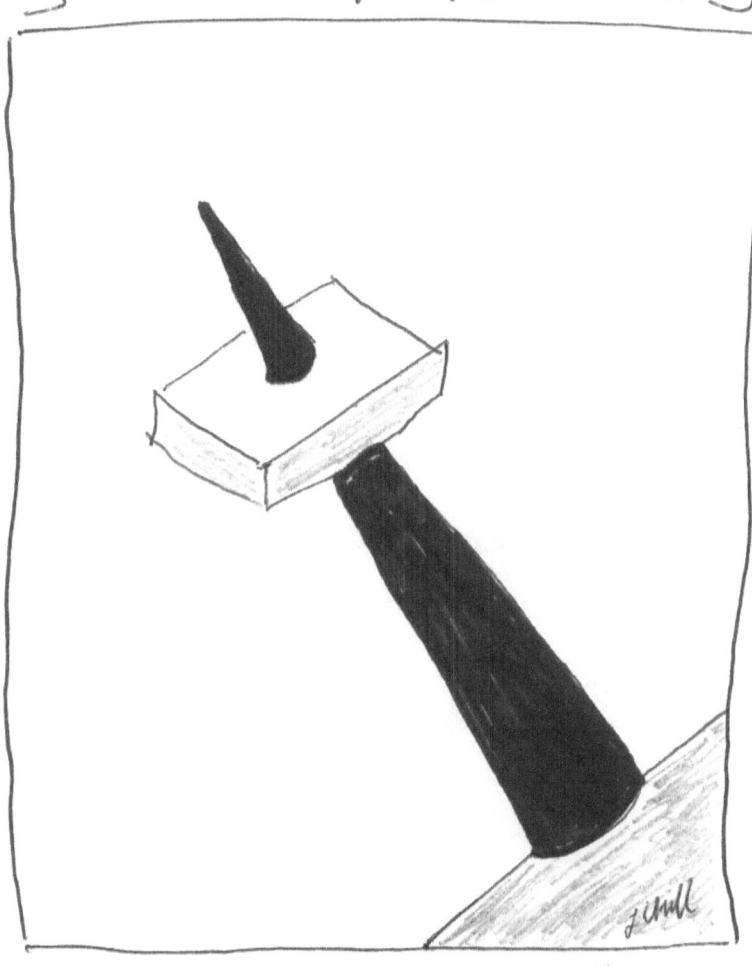

"Unicorn with Impaled Cheese"

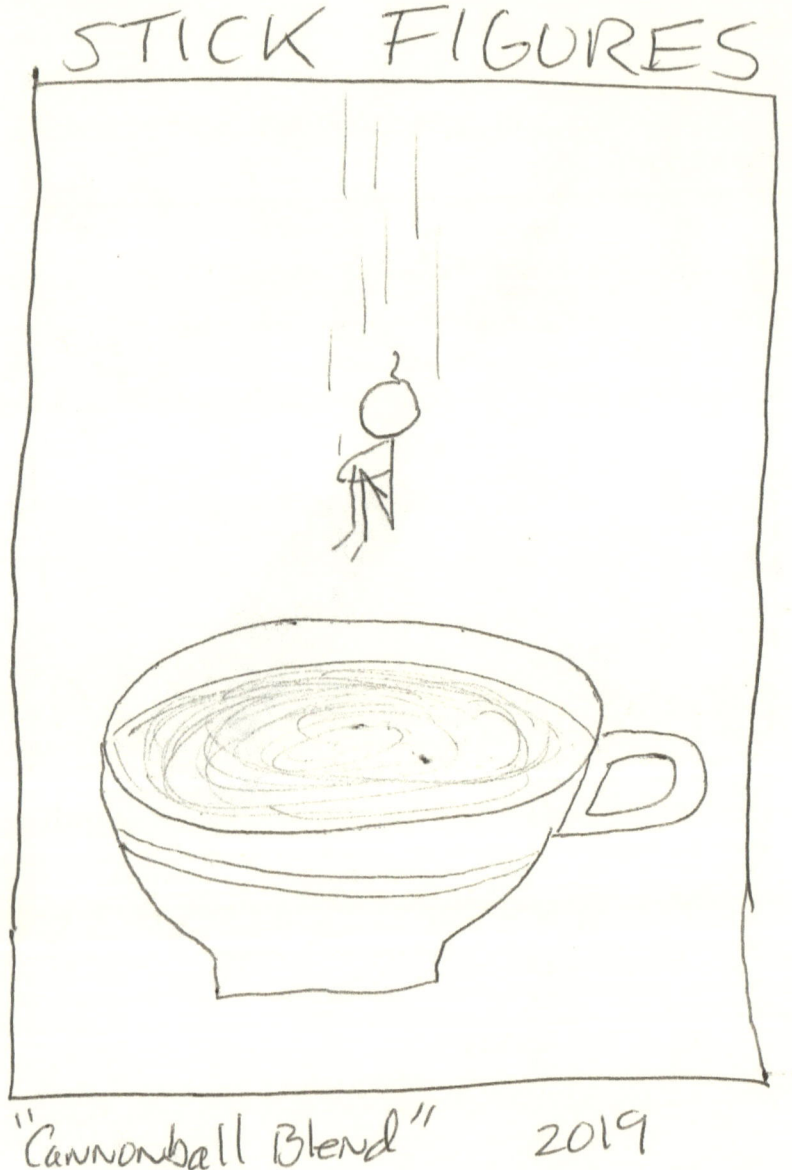

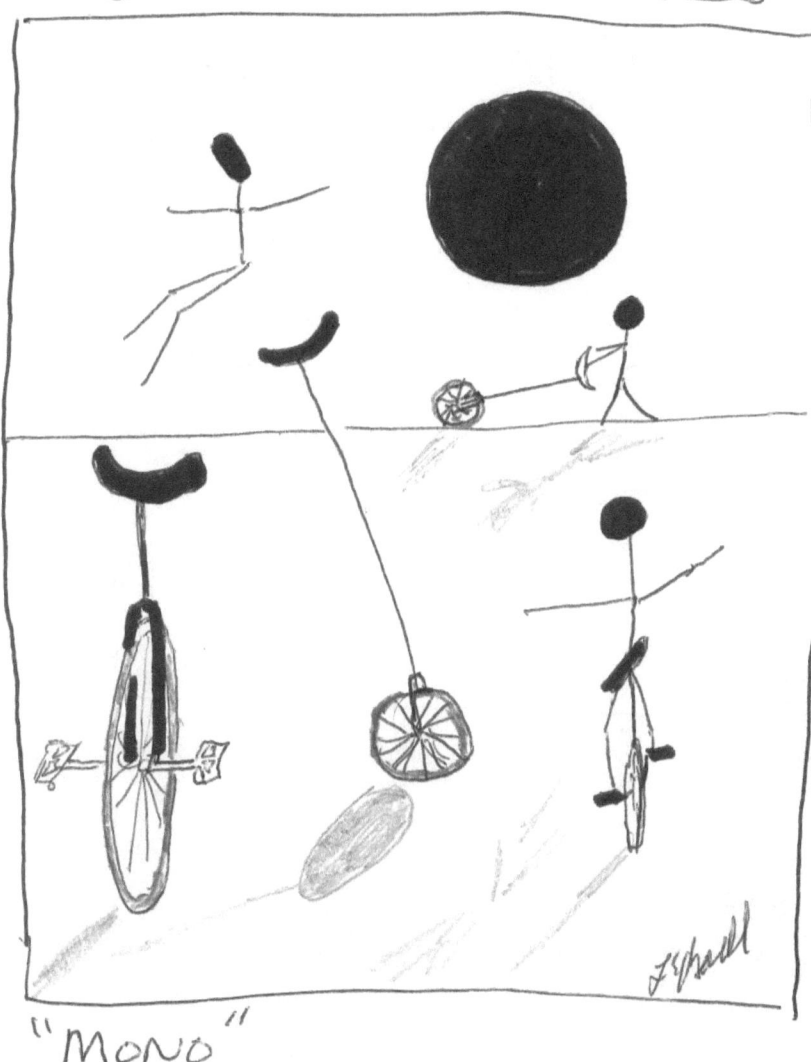

"Mono"

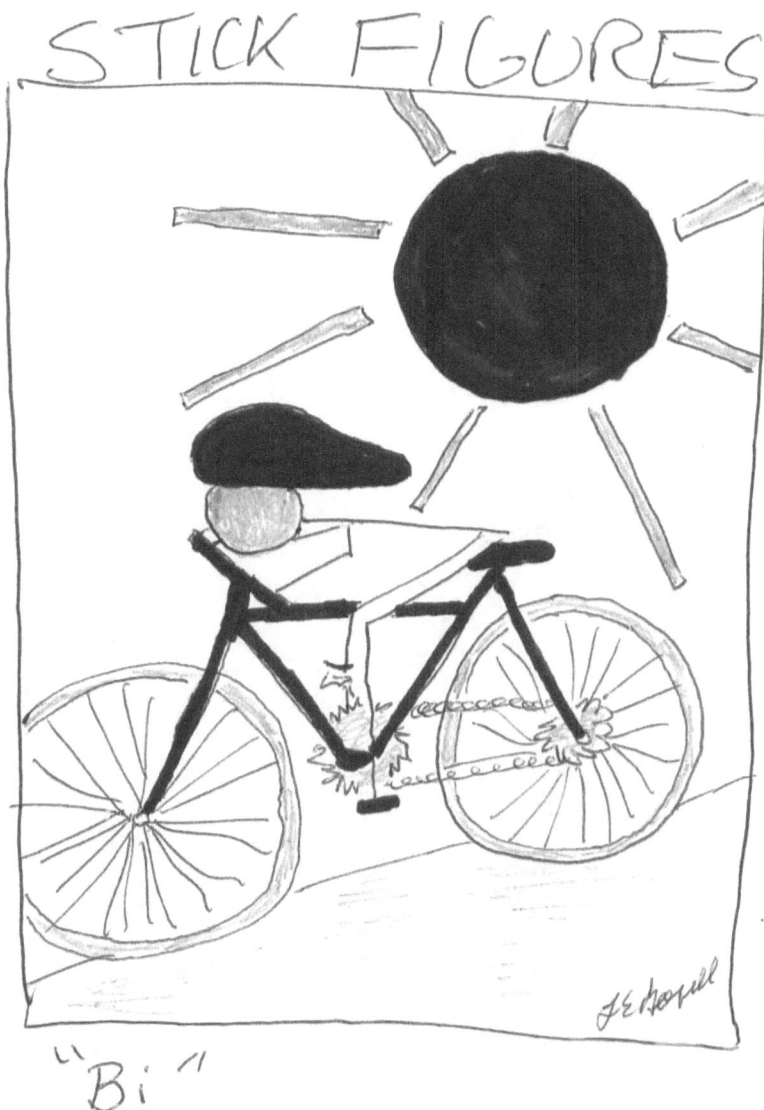

STICK FIGURES

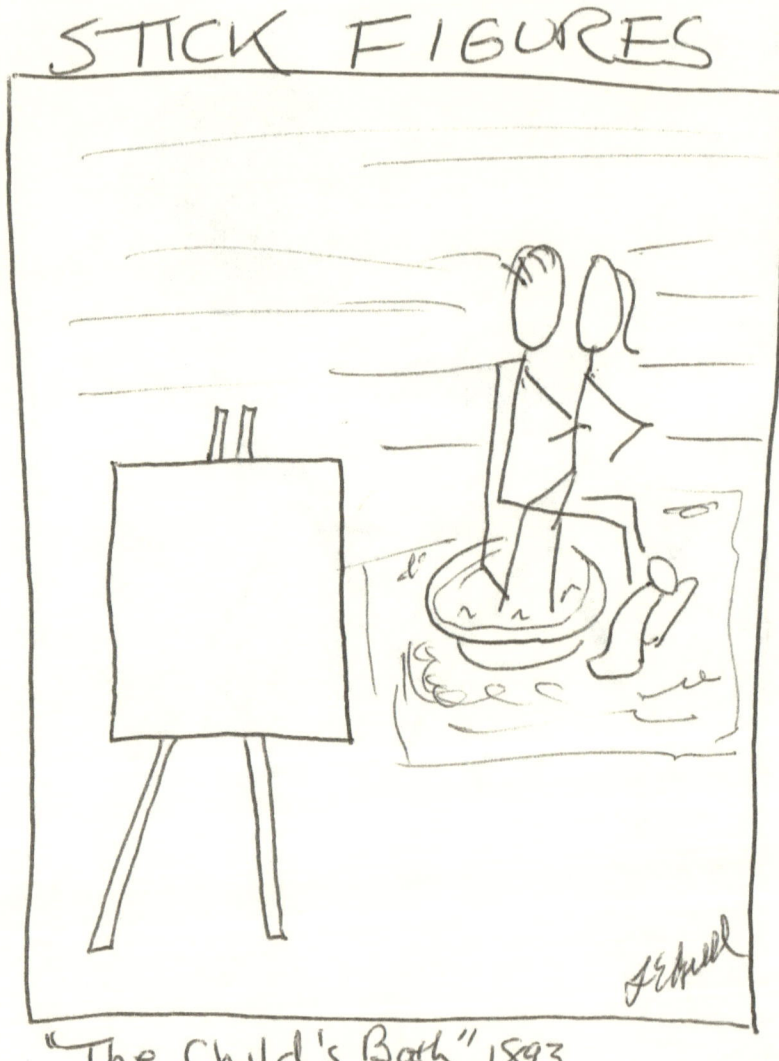

"The Child's Bath", 1893
Mary Cassatt
Artist's perspective

"Tri"

"The Flosser" 2019

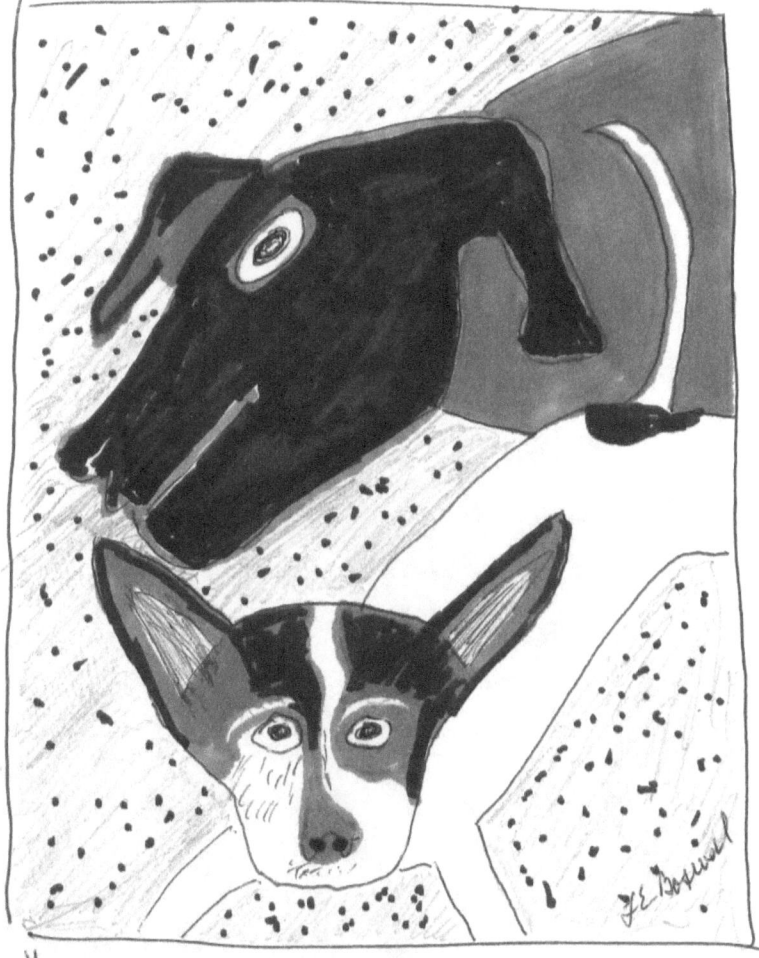

"Shadow and Cinder" 2019

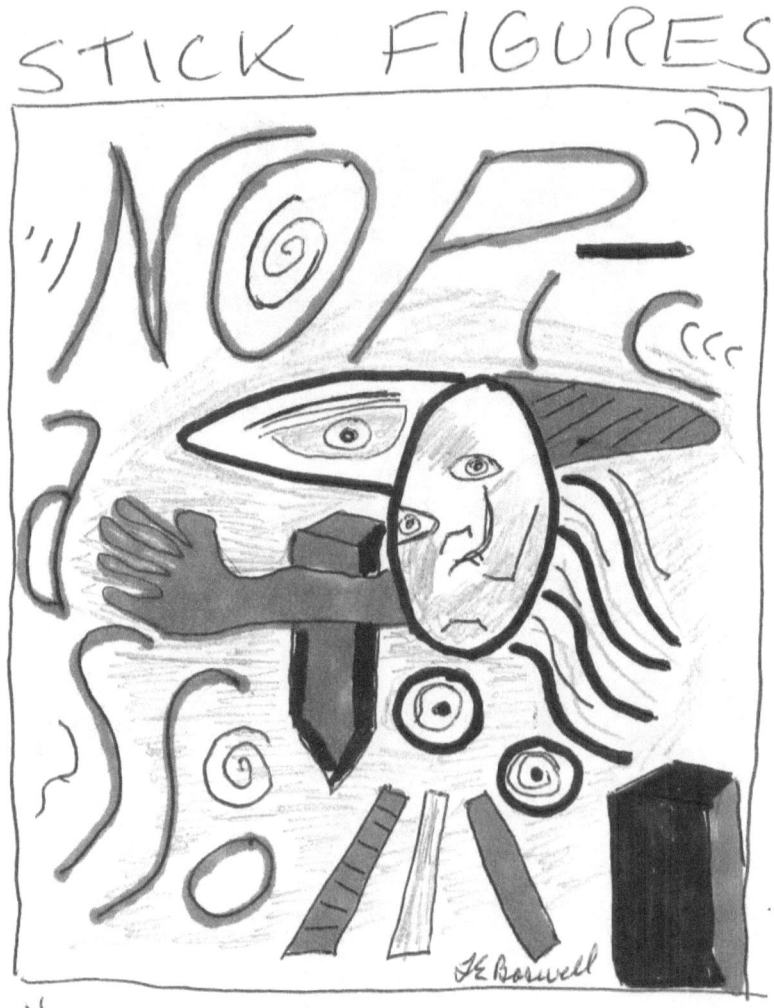

"No Picasso"

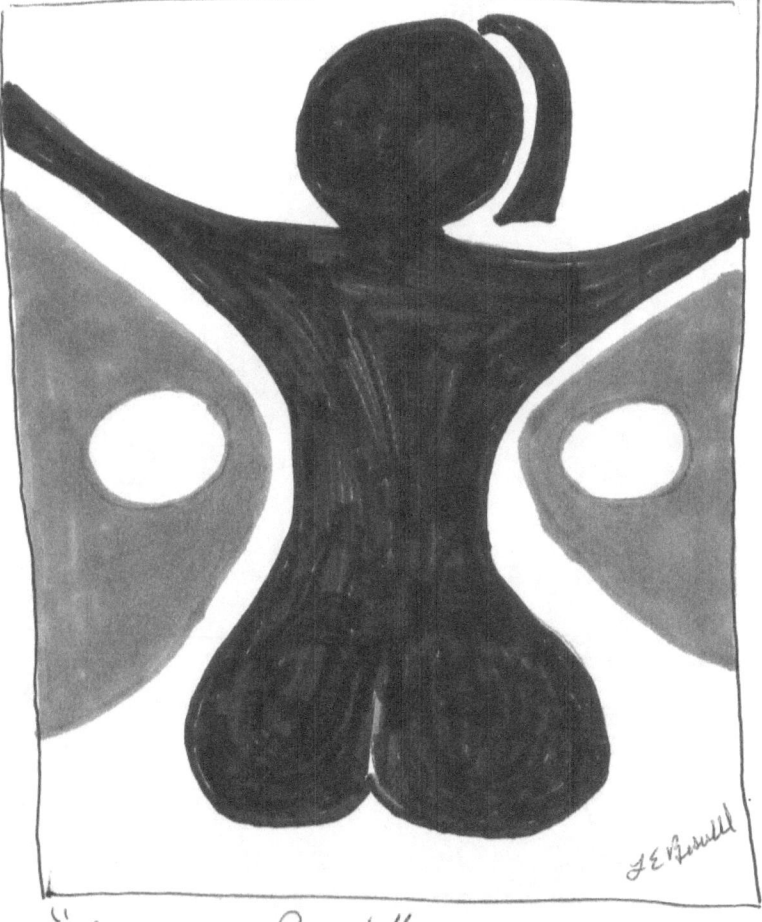
"Nude in a Pinch" 2019
or, Cat/Woman

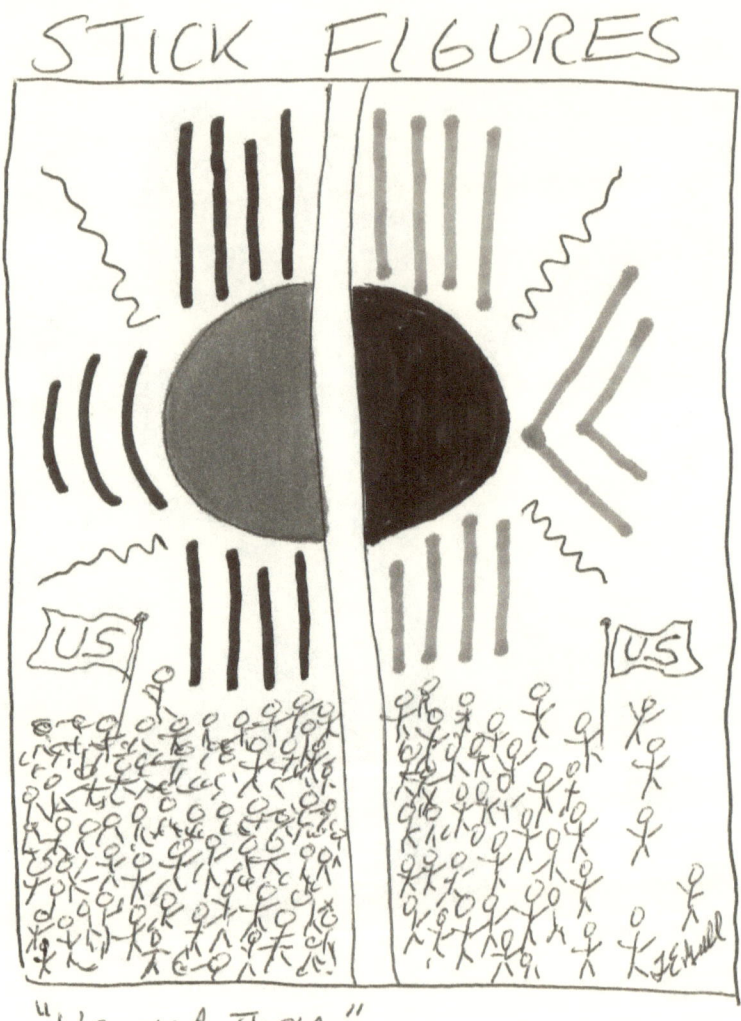

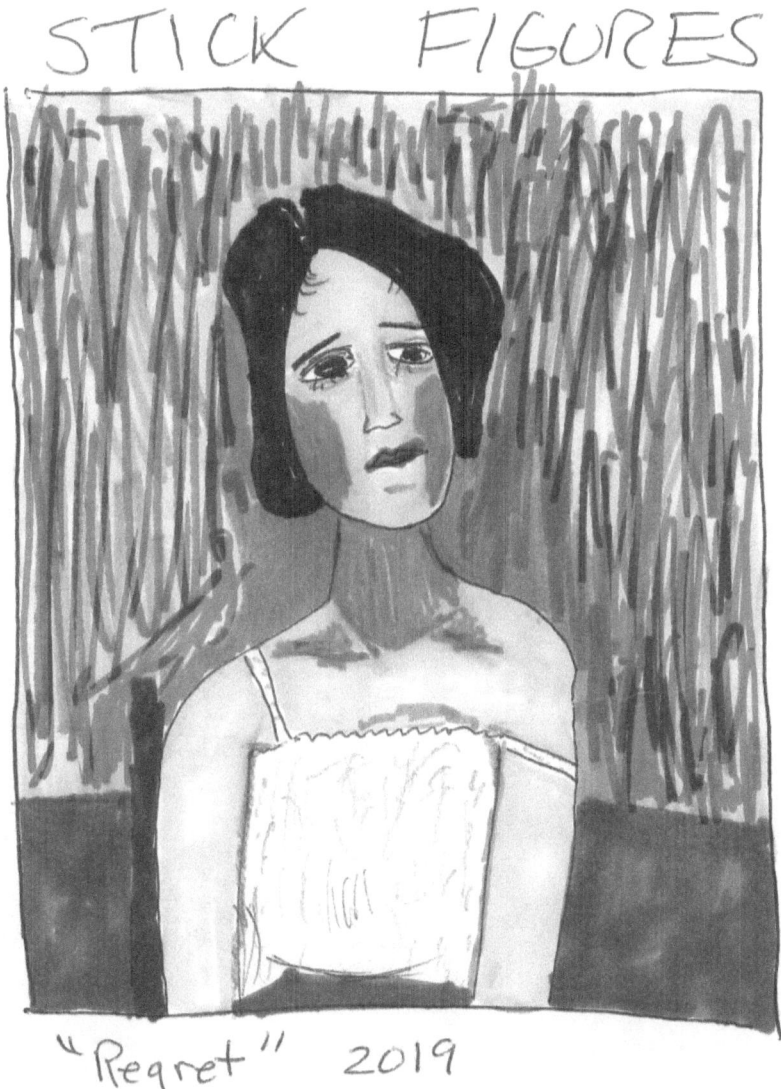

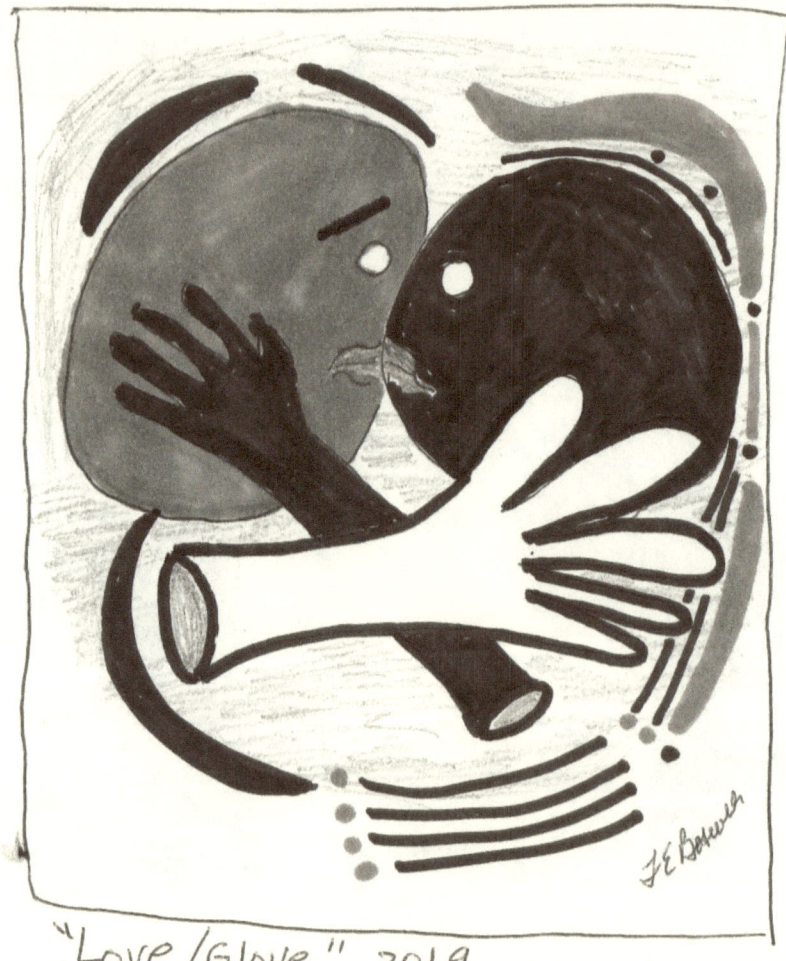

STICK FIGURES

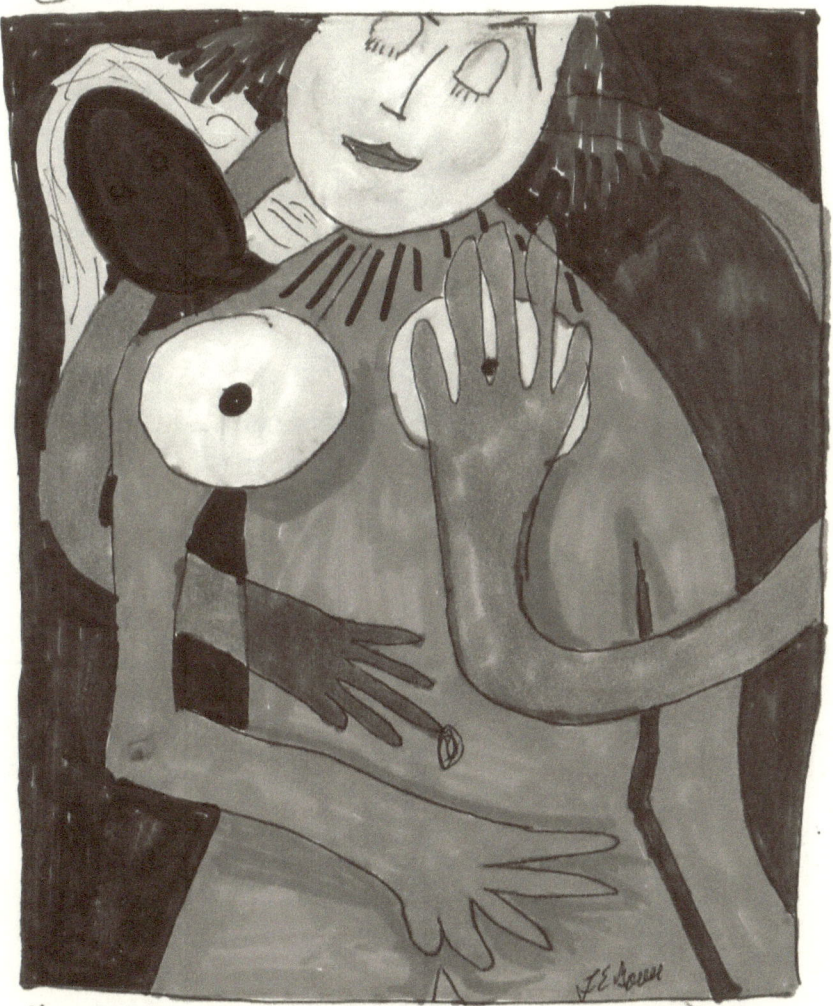

"In her imagined evenings" 2019

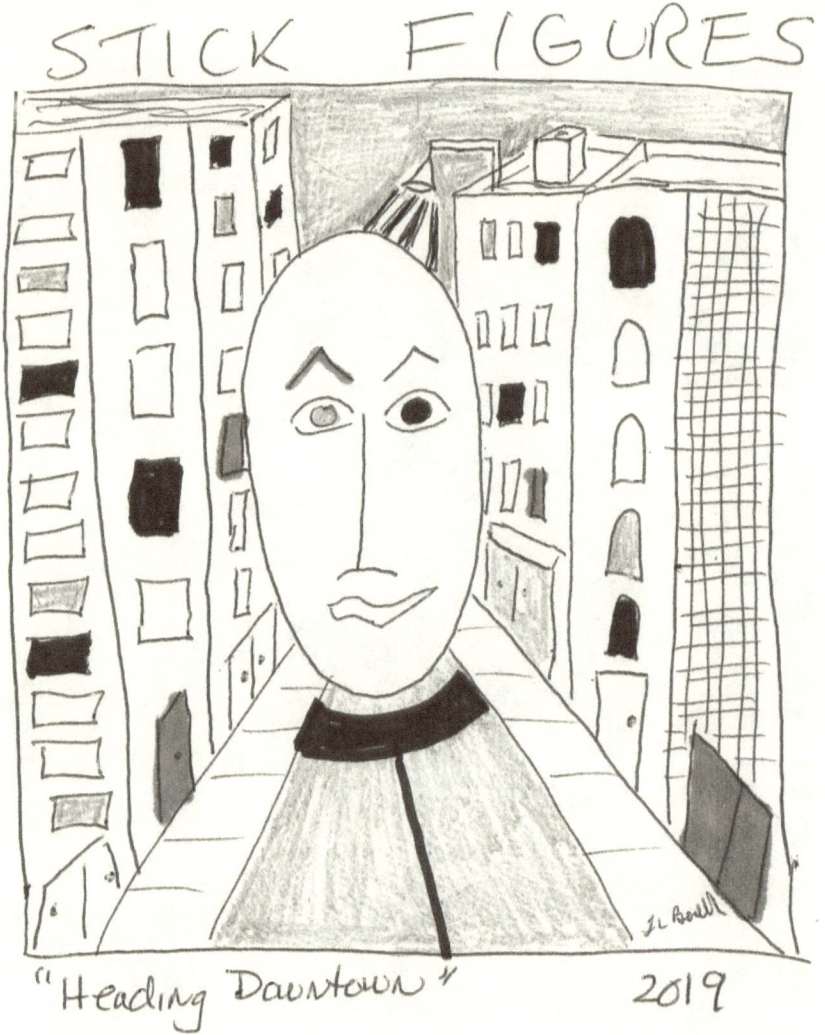

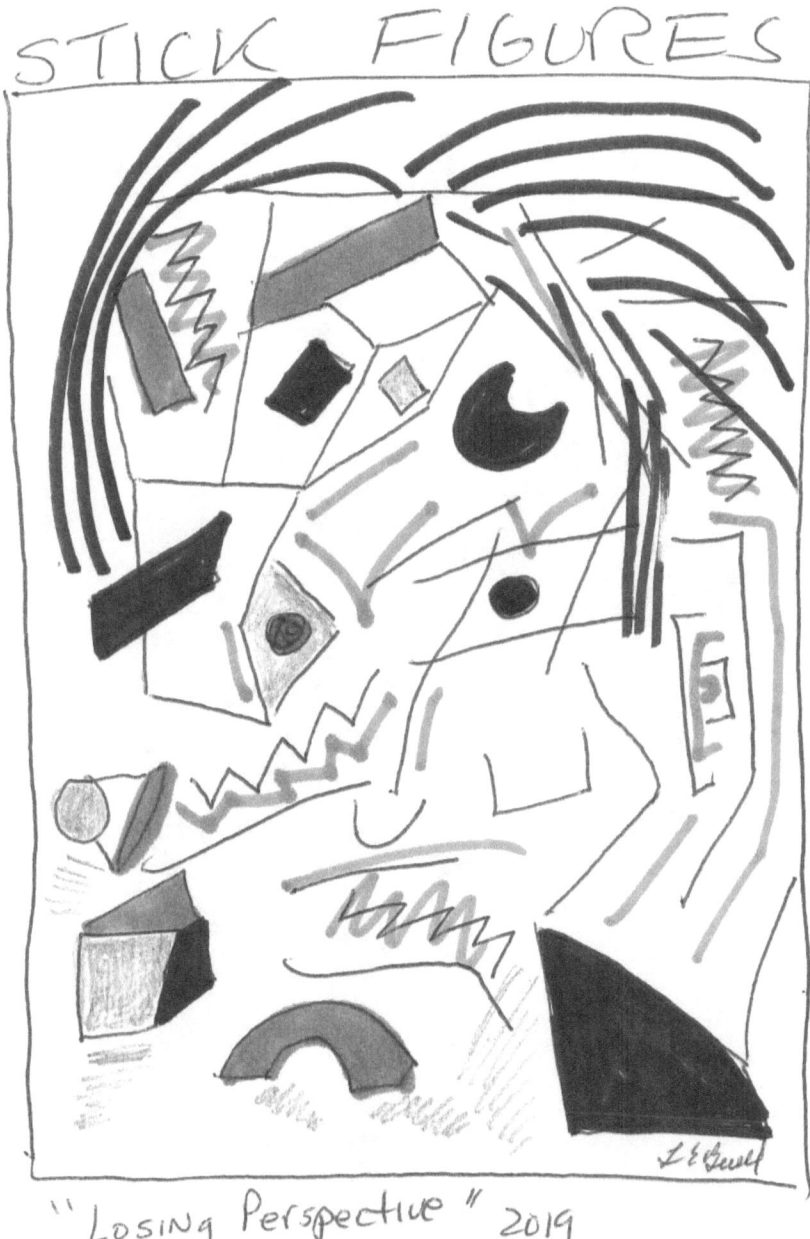

"Losing Perspective" 2019

"Walkabout" 2019

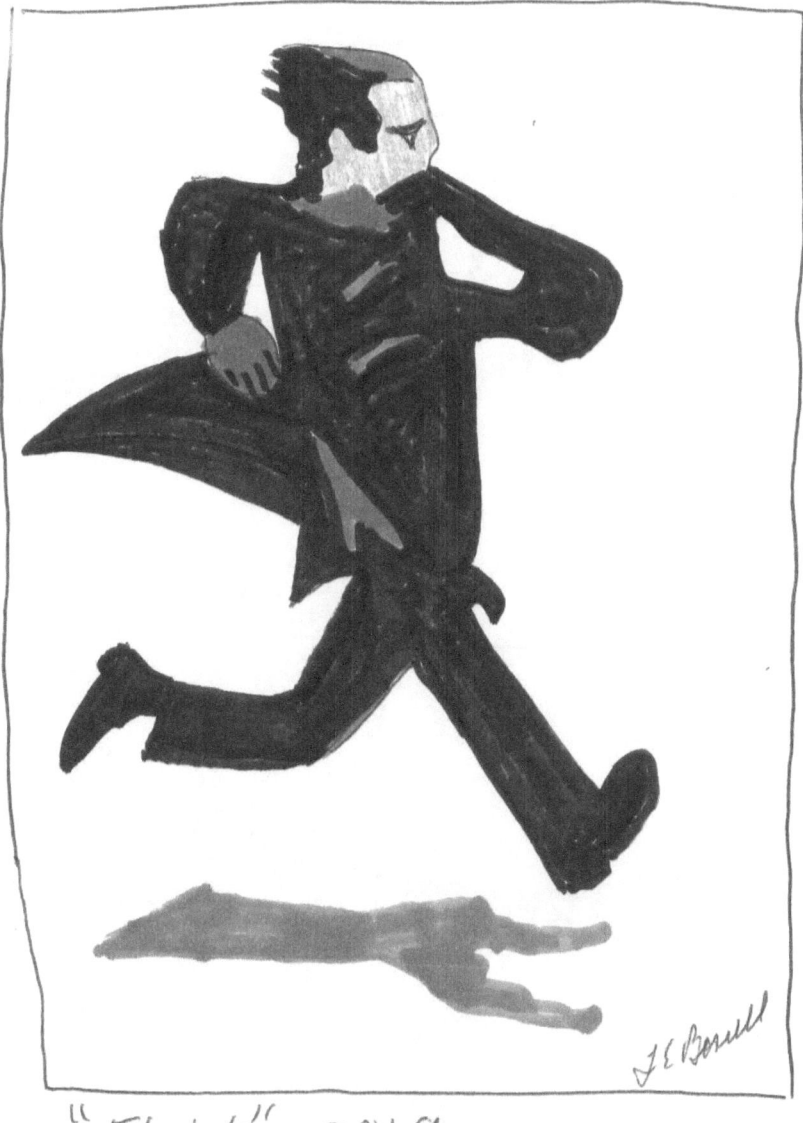

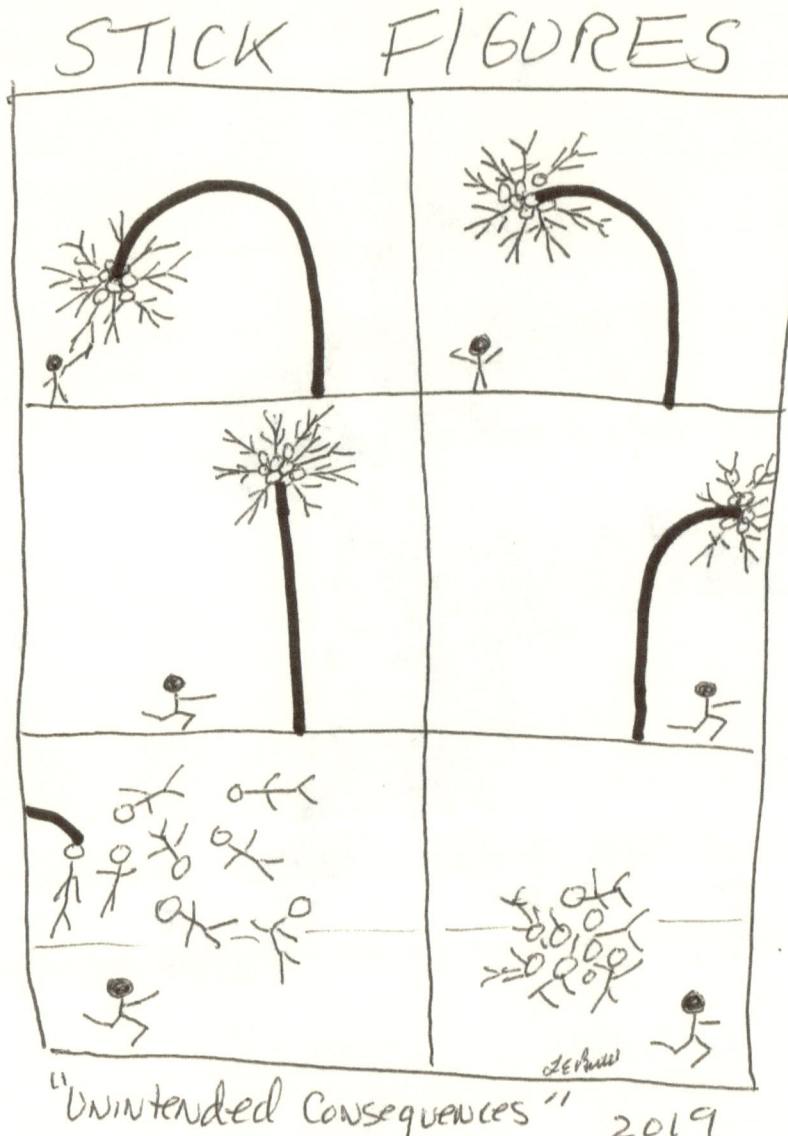

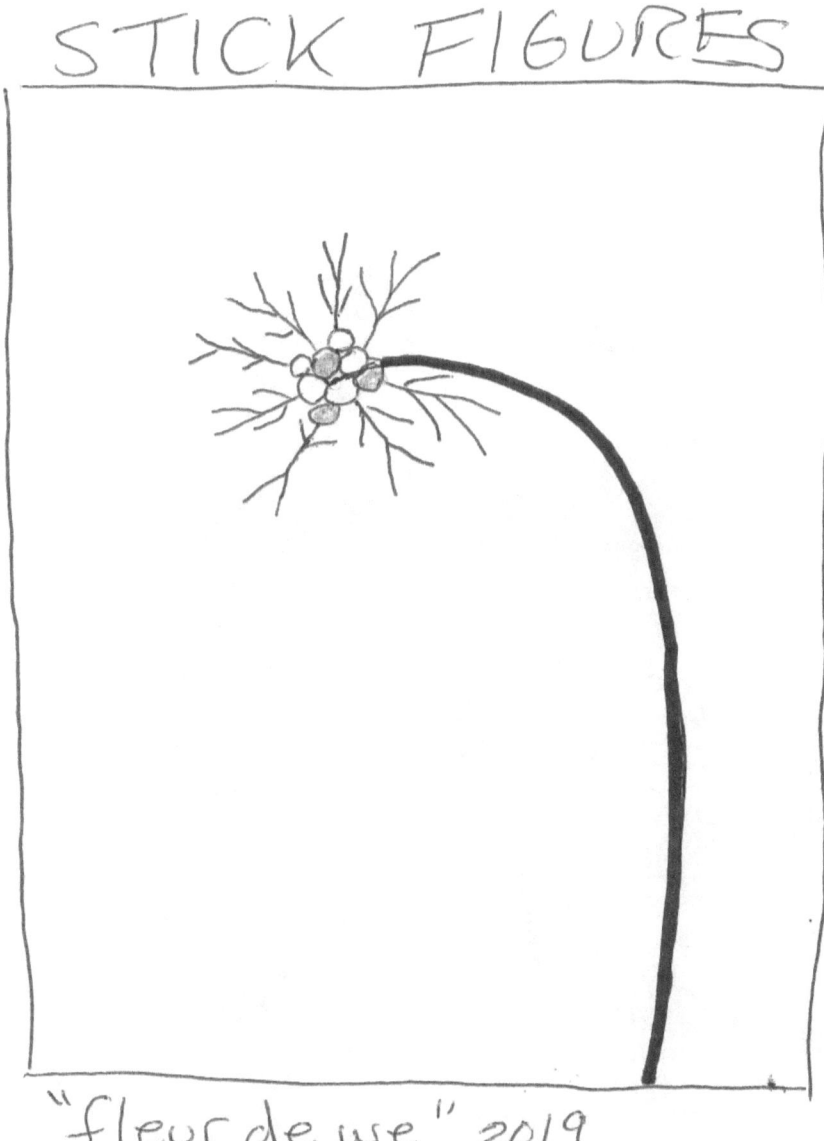

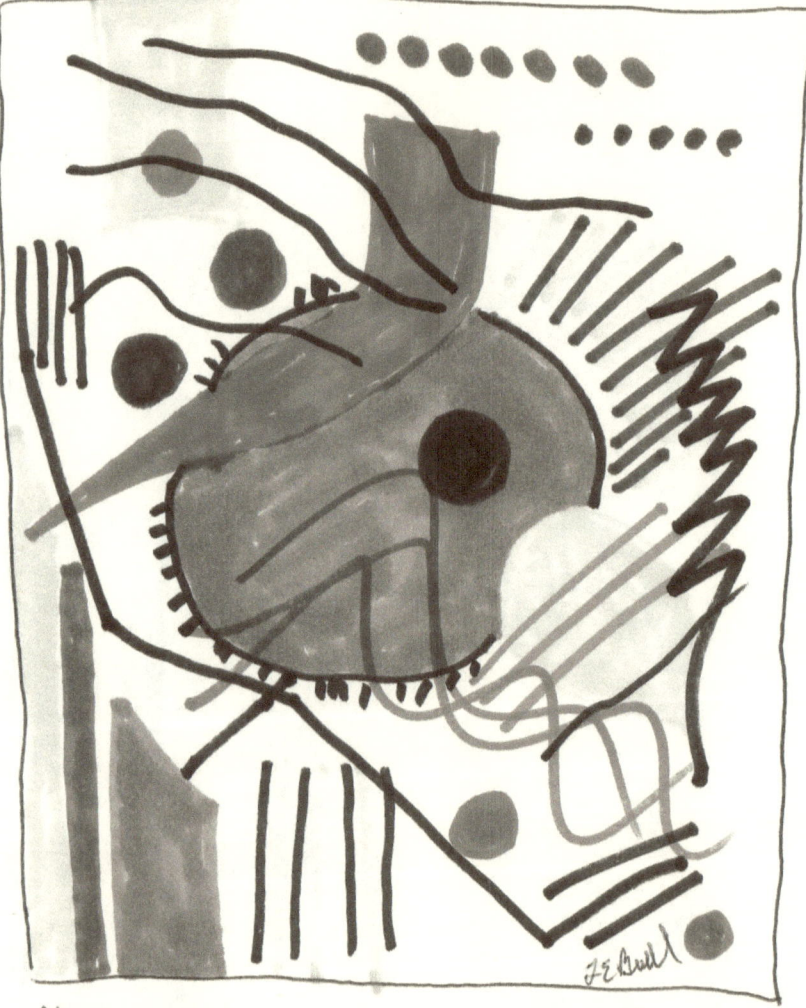

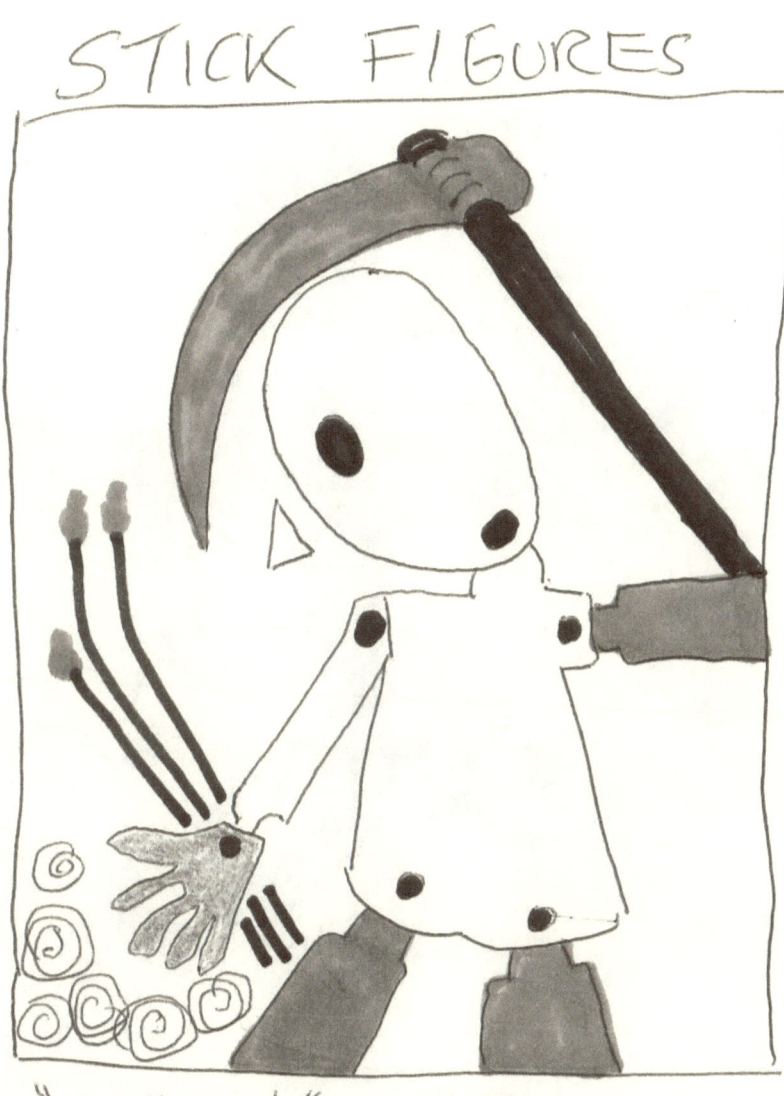
"The Harvest" 2019

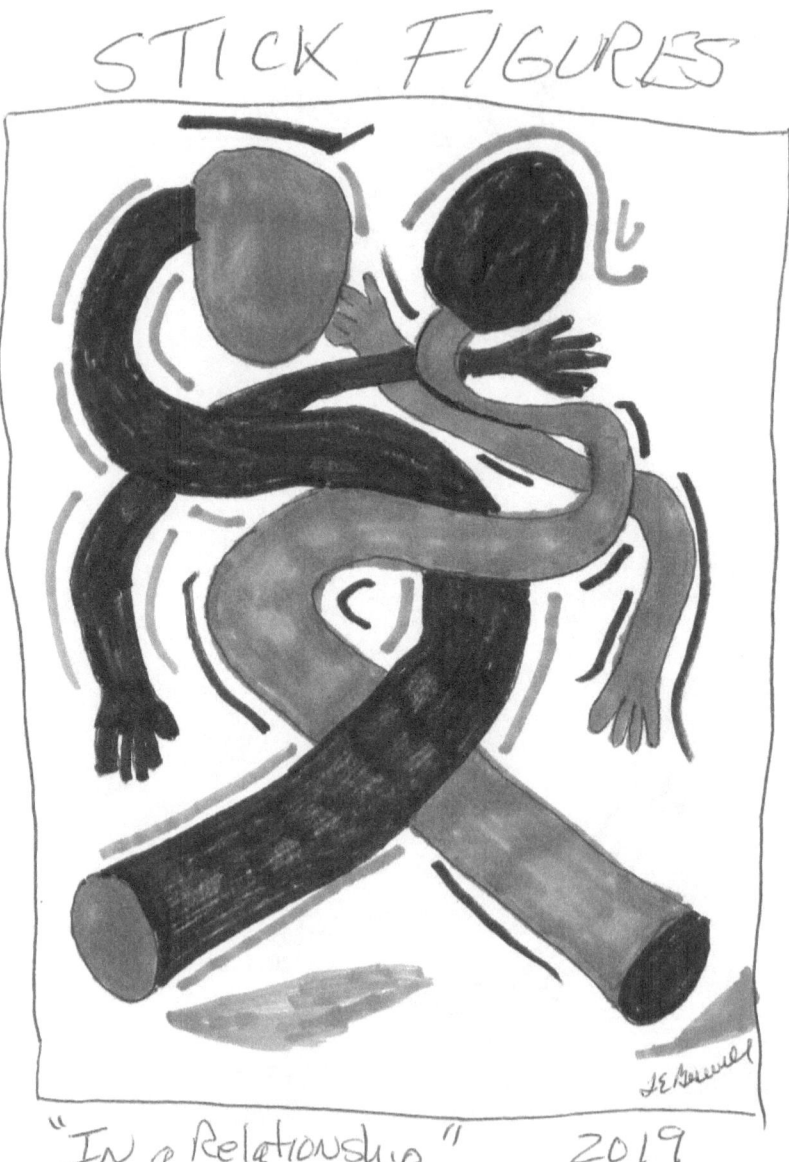

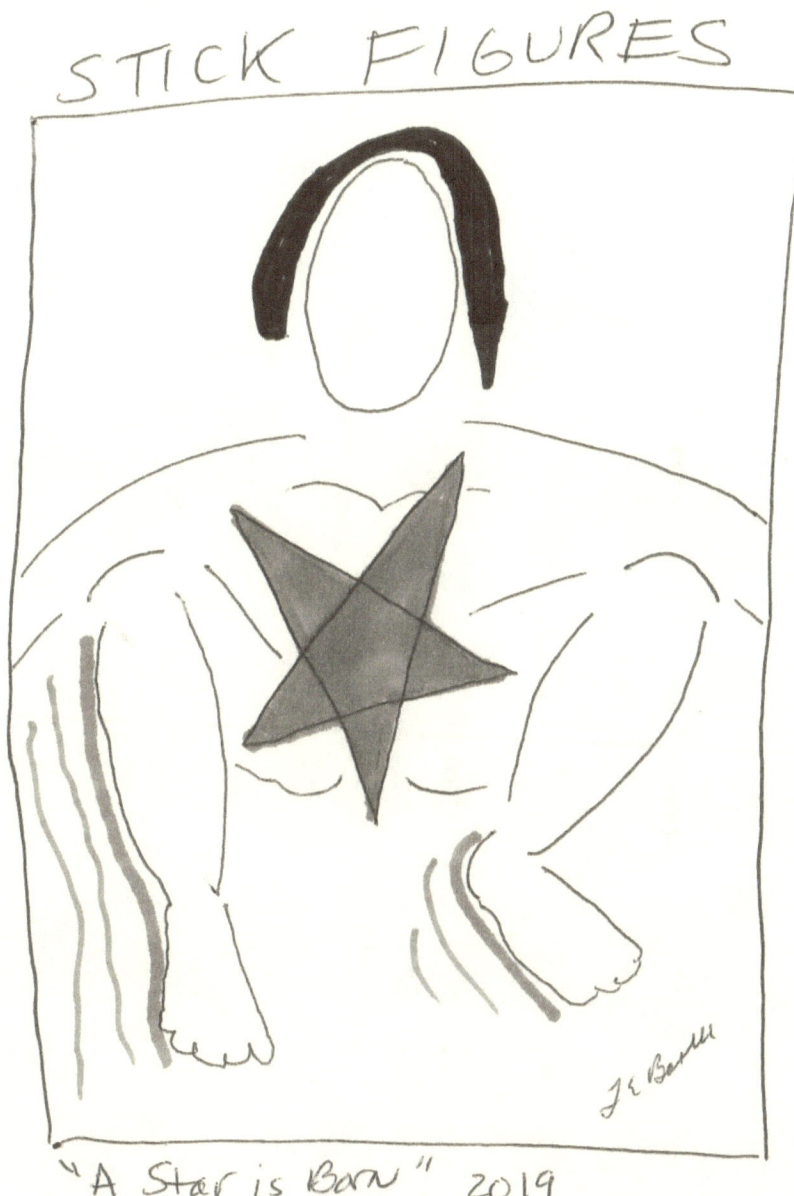

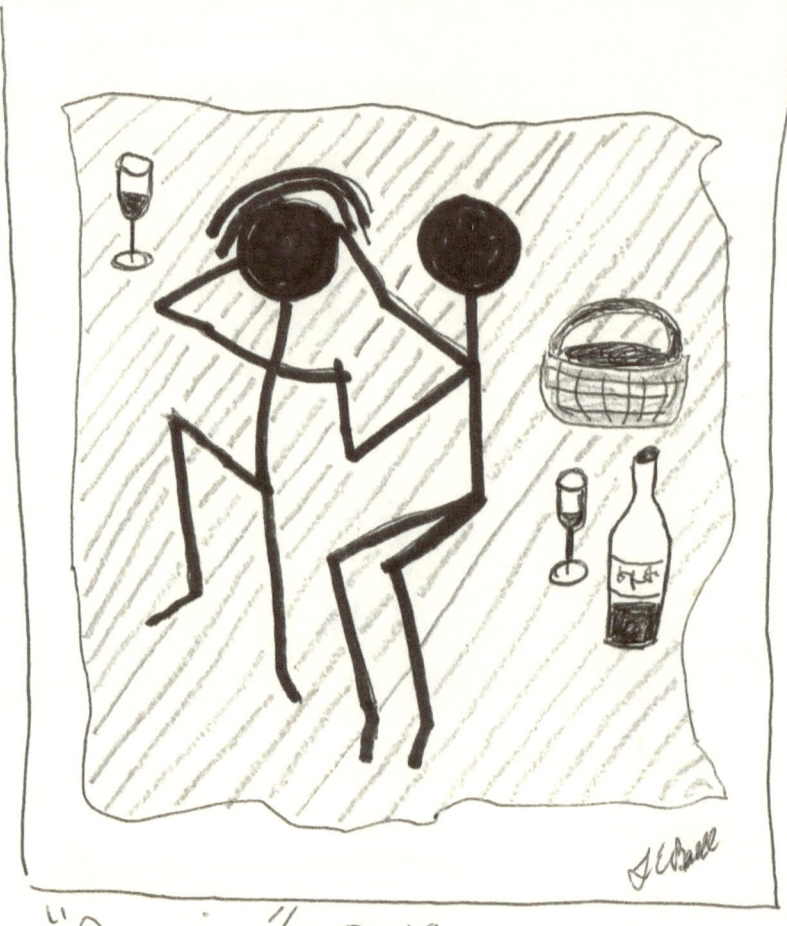

Part Six
A Miscellany of Fun

Now that you're grounded in all things Boswell, you will not be surprised to learn that Boswell enjoyed having fun. The twenty-seven outrageous stick-figure drawings that follow are wonderful examples of his sense of humor. A few are even directed at me, and I loved each one, particularly the one that included my faithful dog, Stix. He captured him beautifully.

You'll also find a number of drawings here that arrived too late to classify and place in their proper sections. I apologize, but as you may know, Boswell is not big on deadlines. So it goes.

Anyway, get ready for a giggle or six.

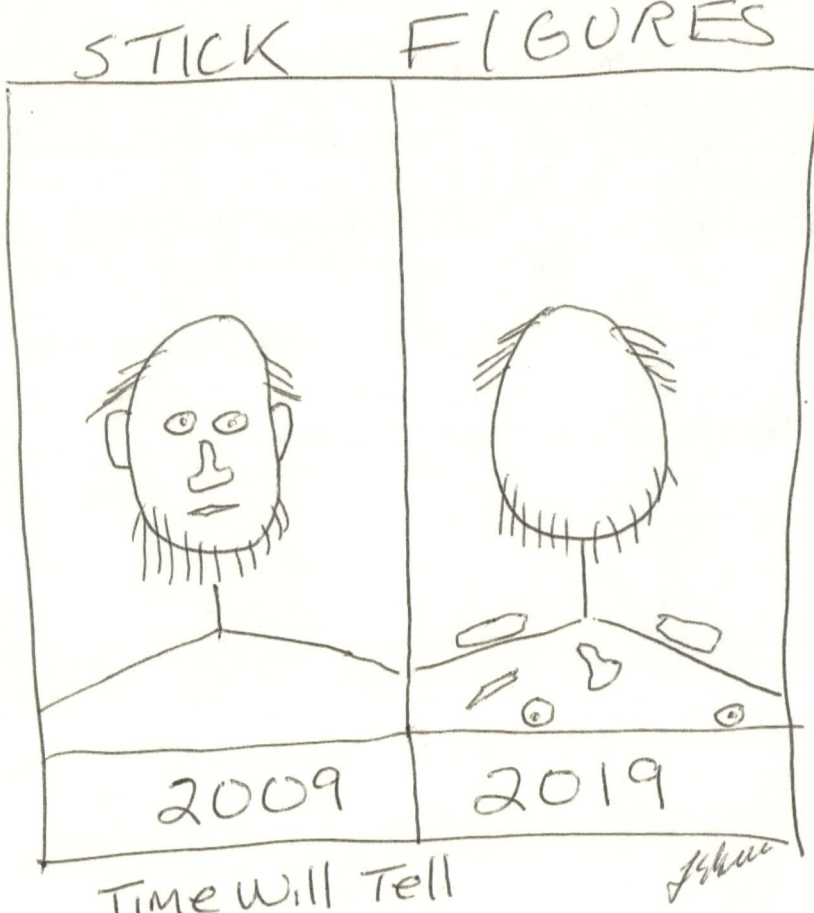

STICK FIGURES

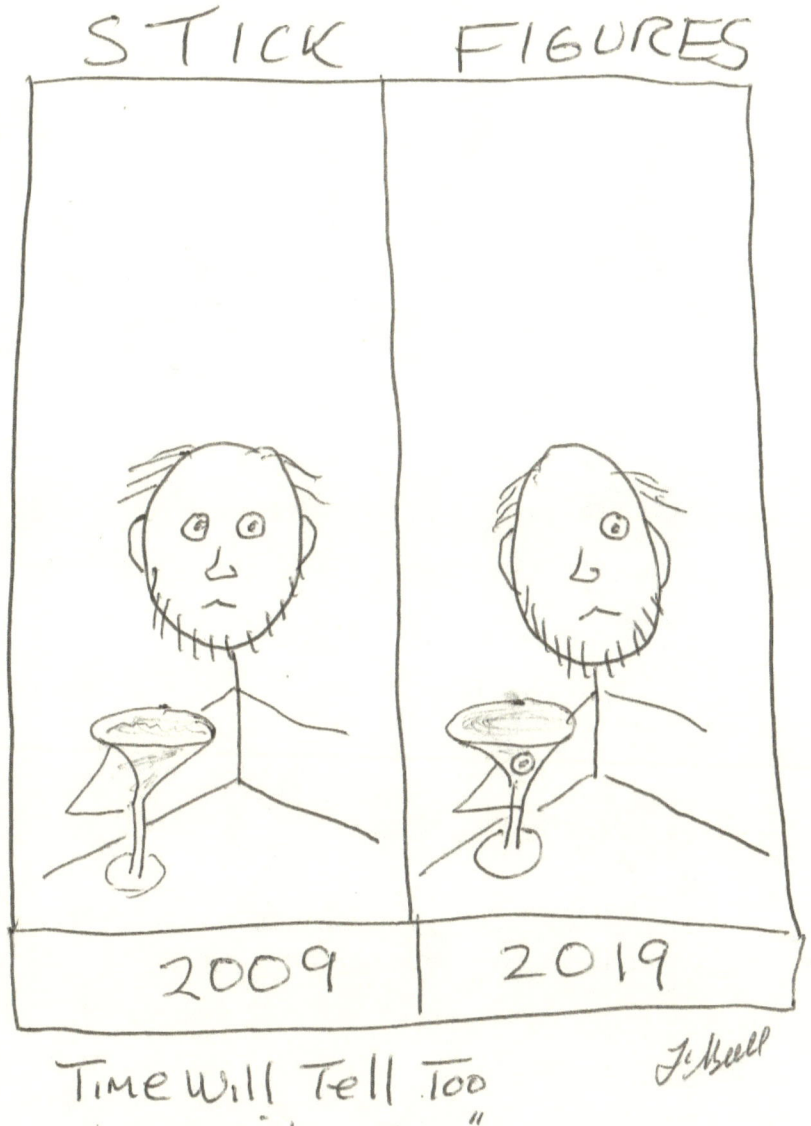

Time Will Tell Too
"A Martini In Time"

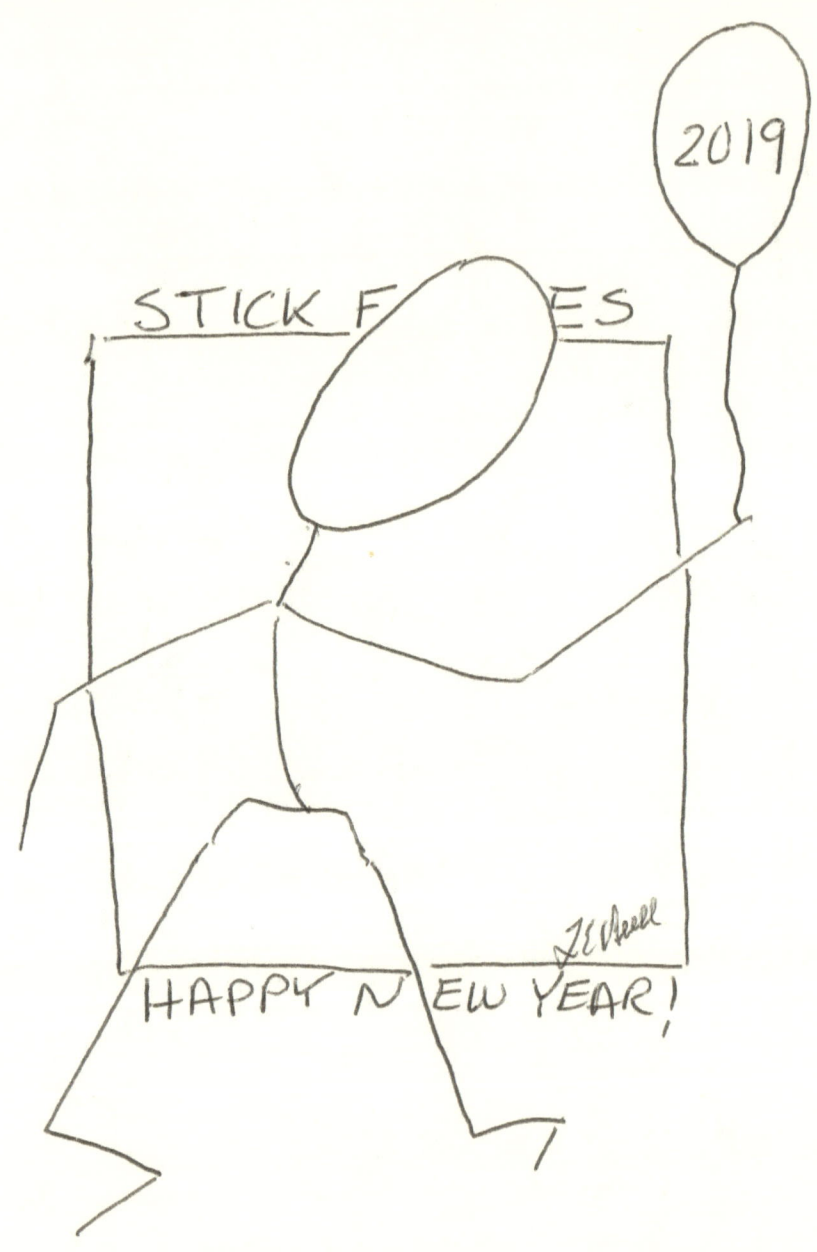

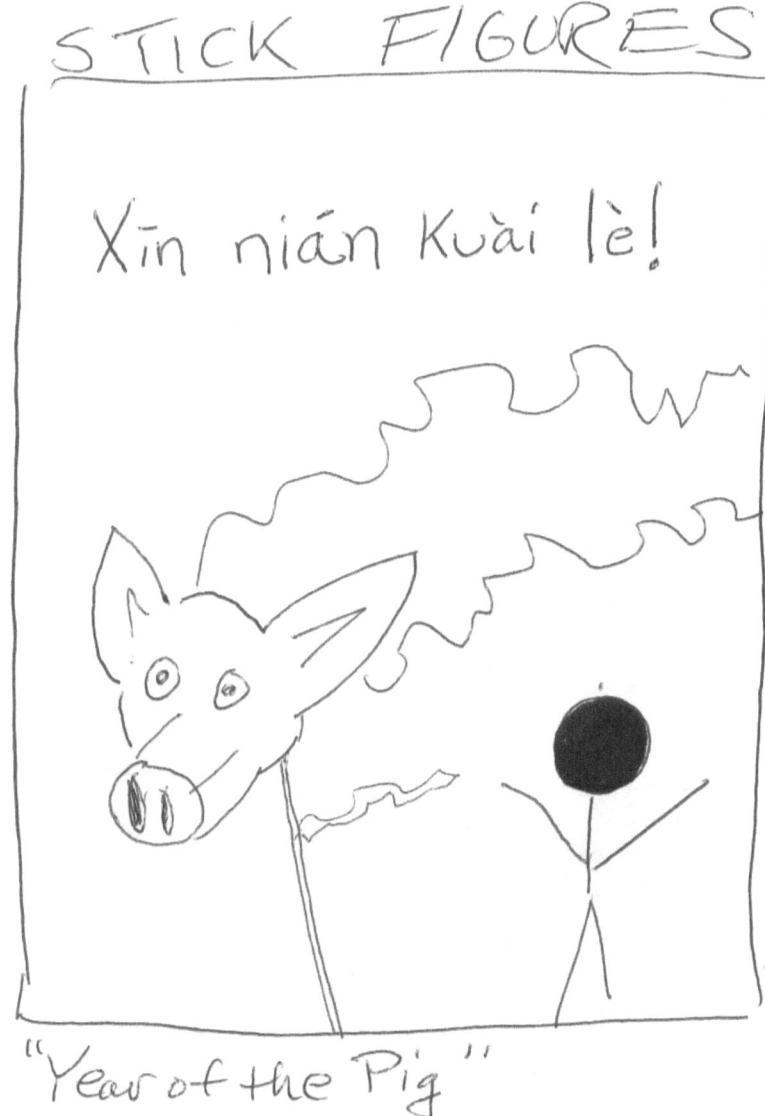

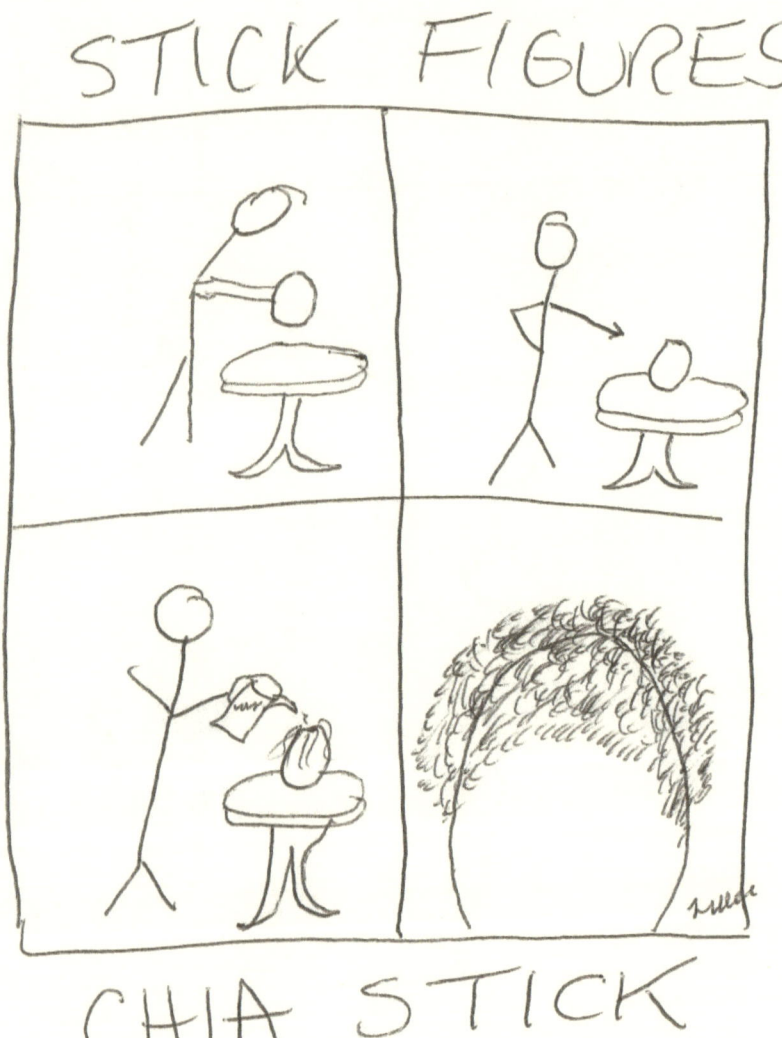

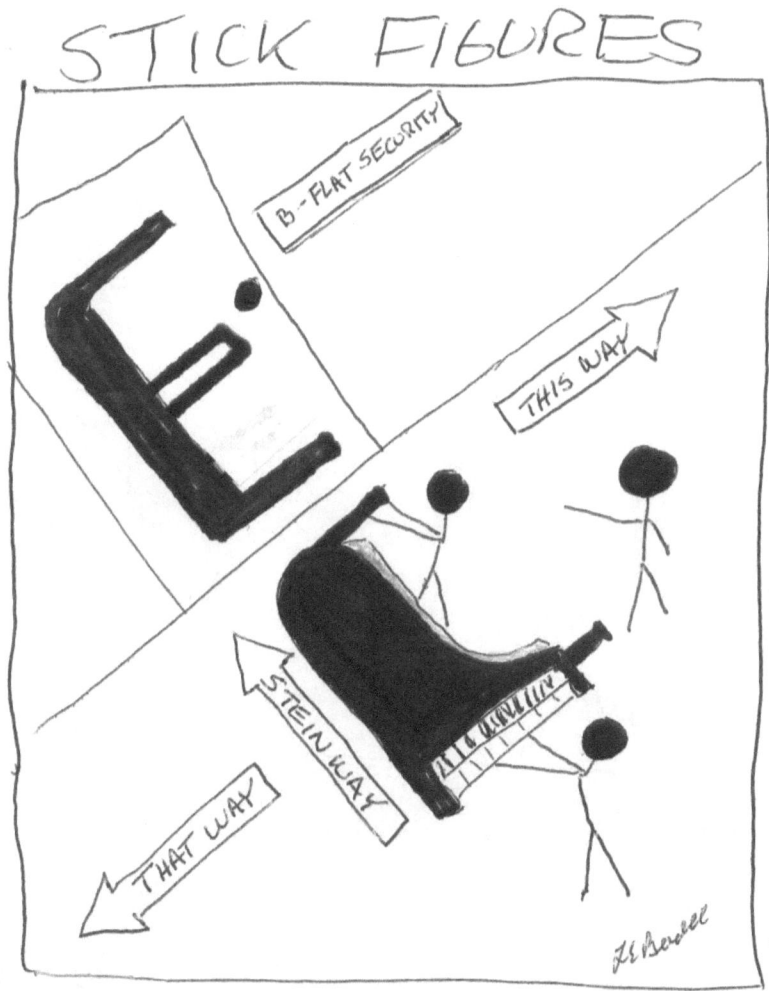

STICK FIGURES

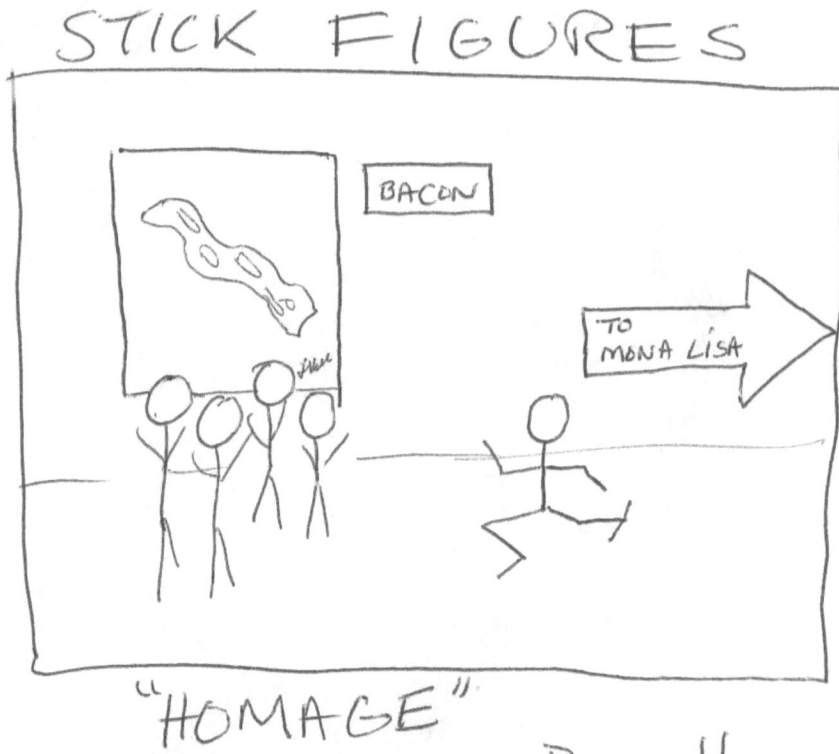

STICK FIGURES

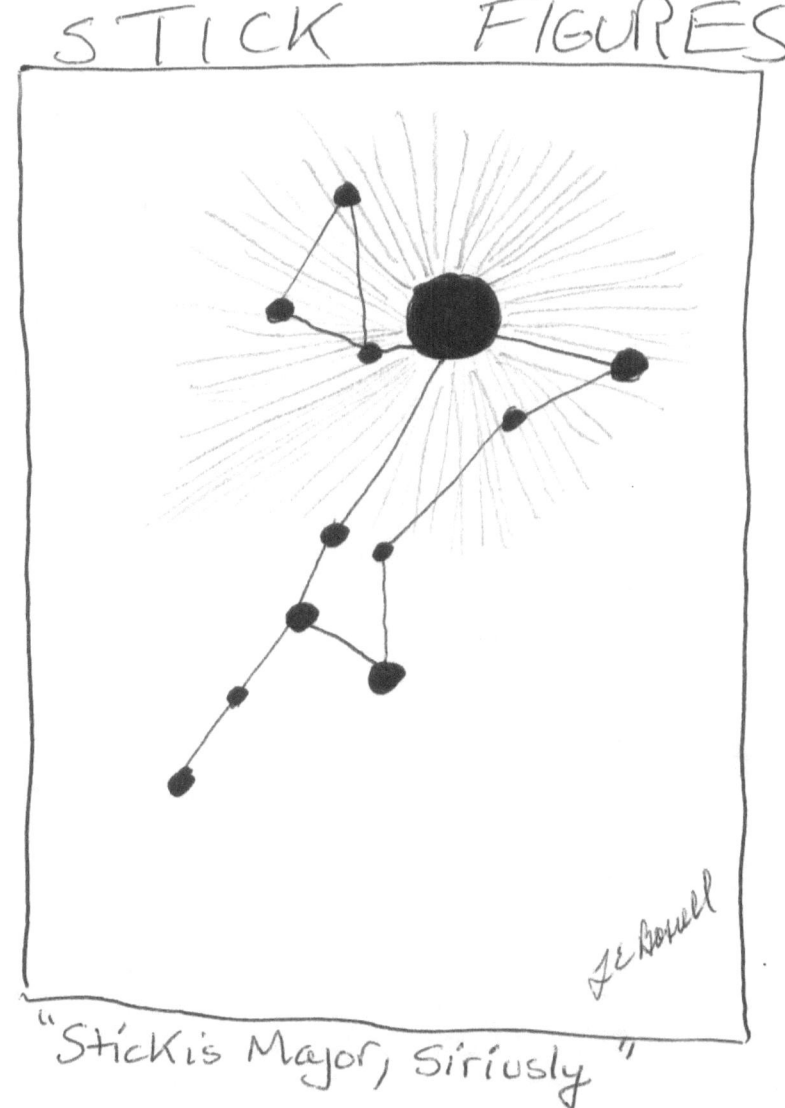

STICK FIGURES

"Edgy fun!" — STICKNEWS

YOU STICK BASTARD

ANOTHER STICKY STICKERSON ADVENTURE THING!

LEN BOSWELL

STICK FIGURES

STICK FIGURES

"Epic!" THE NEW YORK TIMES

THE FURTHER ADVENTURES OF STICKY STICKERSON AND HIS FAITHFUL DOG STIX

LEN BOSWELL

COMING SOON!

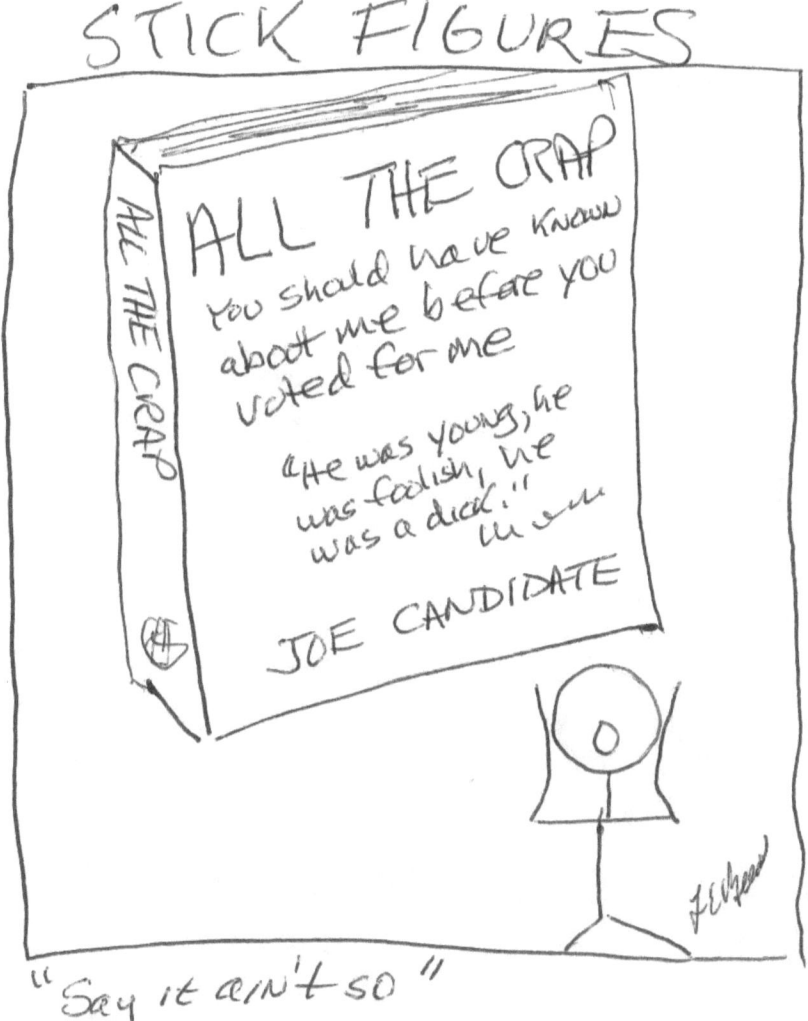

STICK FIGURES

STICK FIGURES

Santa Takes a Tumble

12 Days of Christmas Past for "Kids" Beyond Belief

Len Boswell

Paper $6.95, ebook $2.99, Audible $6.06
AMAZON • AUDIBLE

STICK FIGURES

LUNAR PHASES	HOLIDAY PHASES	
☾	👤	UNSUSPECTING — RUNUP
☽	👤	
○ (FULL)	👤	CHRISTMAS
☾	👤	AFTERMATH
☽	👤	OPTIMISTIC

— SYNCHRONY —

STICK FIGURES

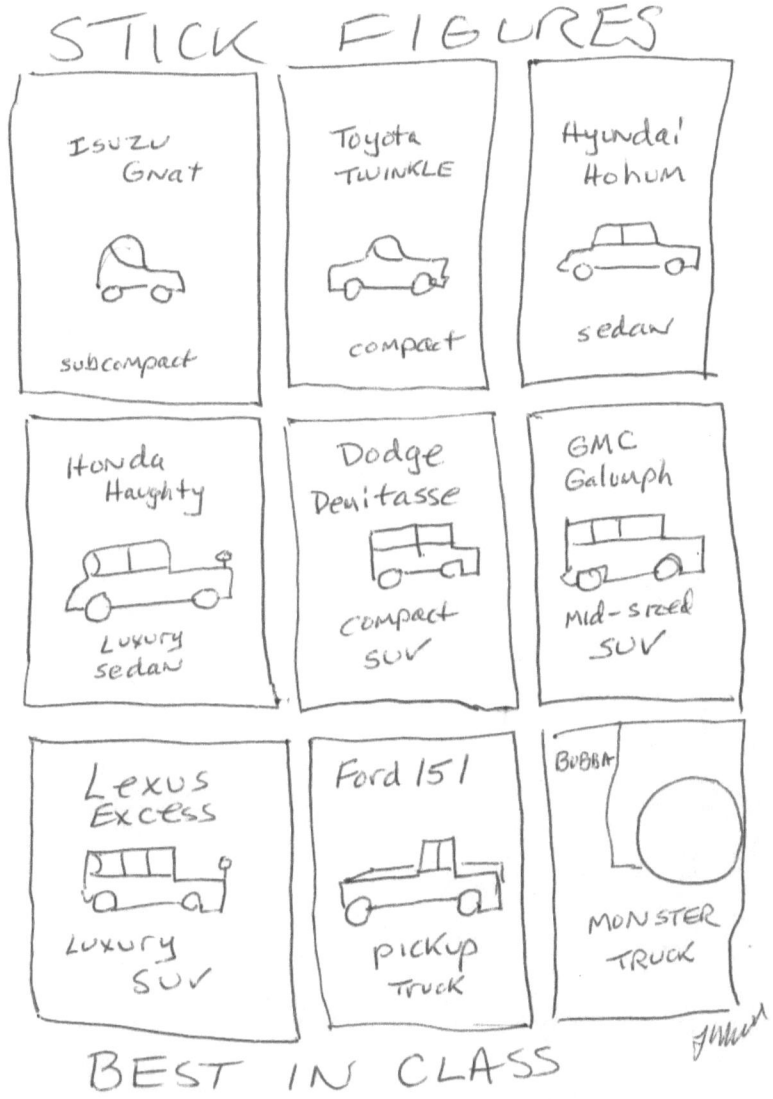

Cocoon of Bitterness and Resentment

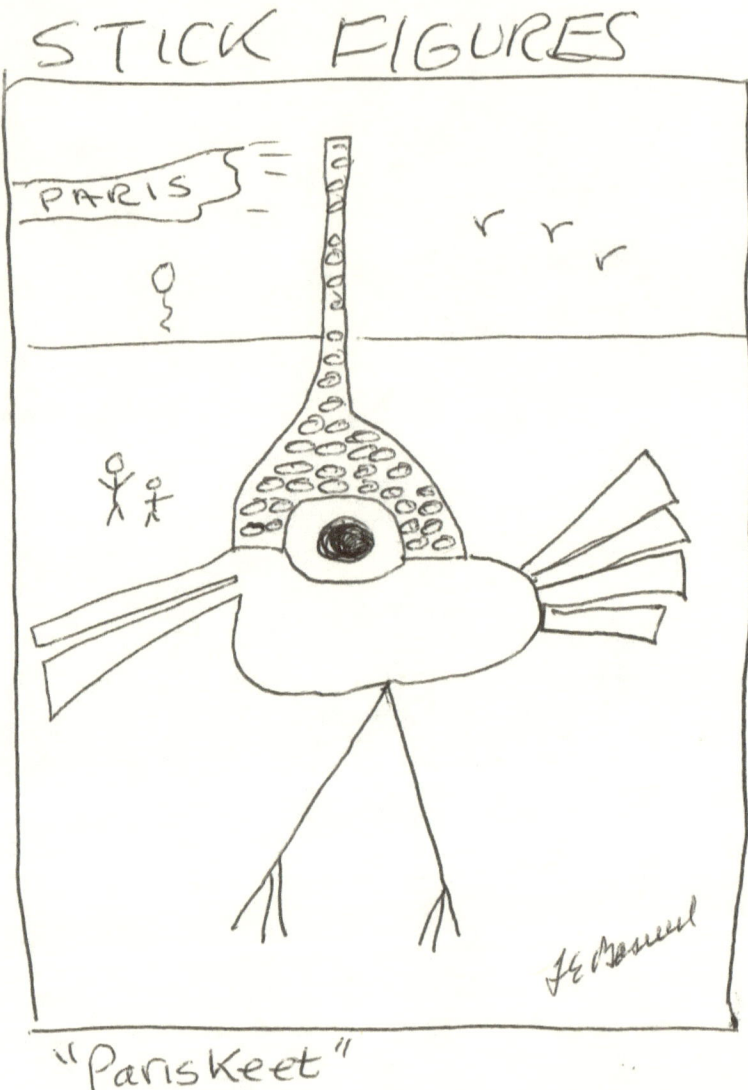
"Pariskeet"

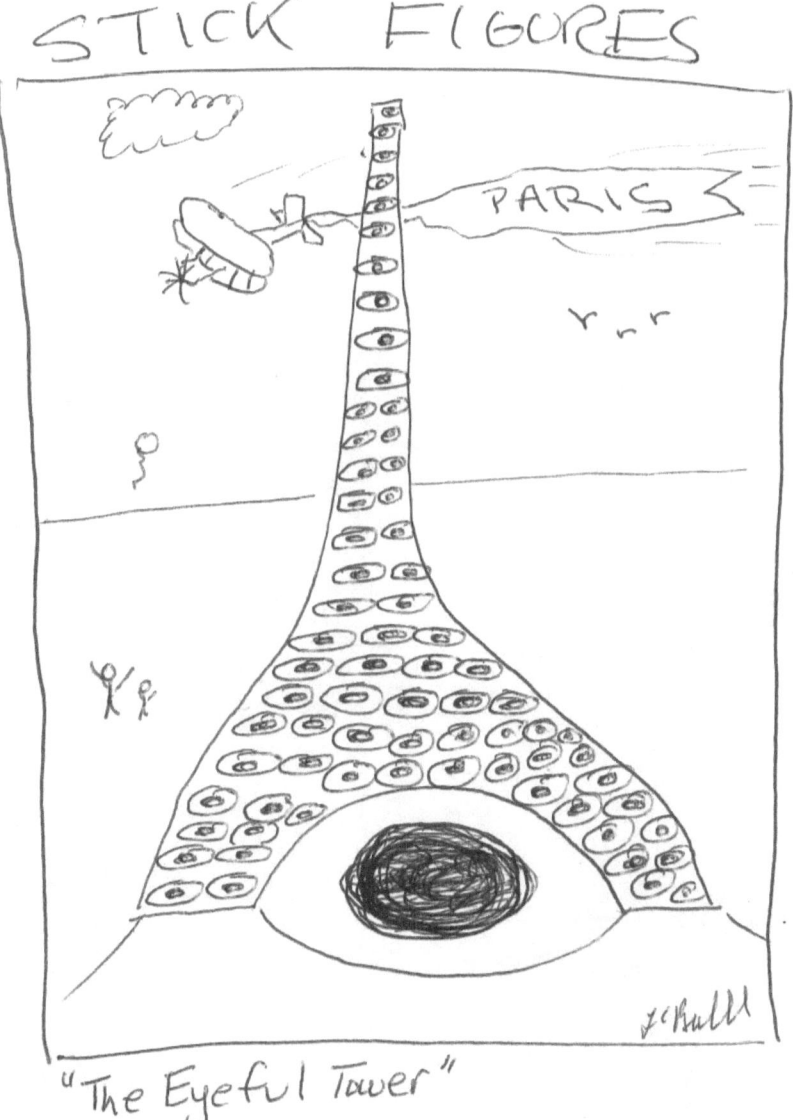

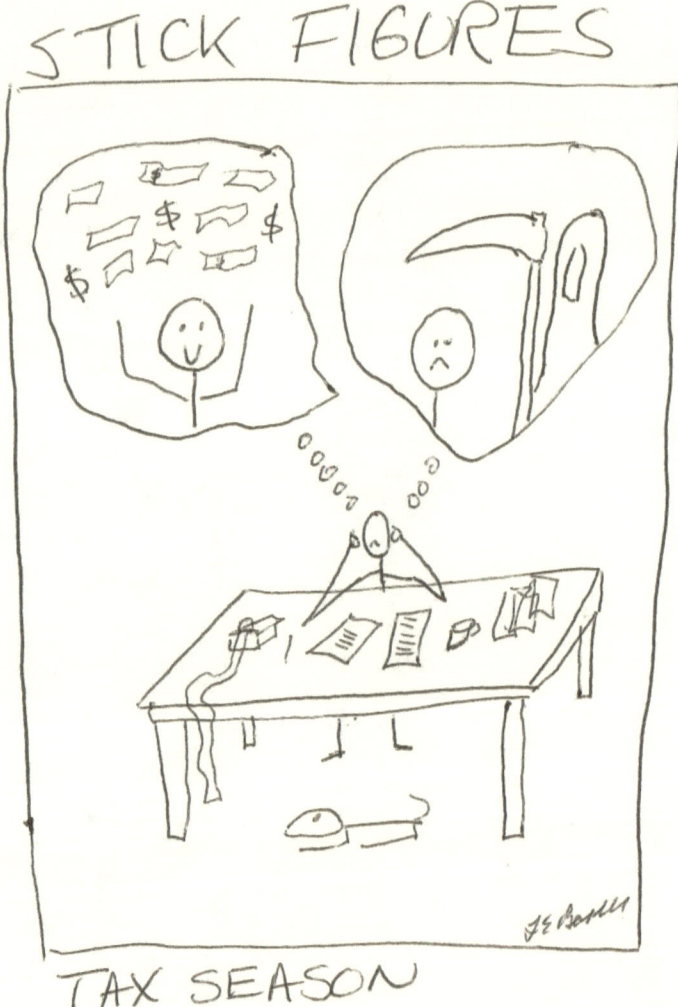

STICK FIGURES

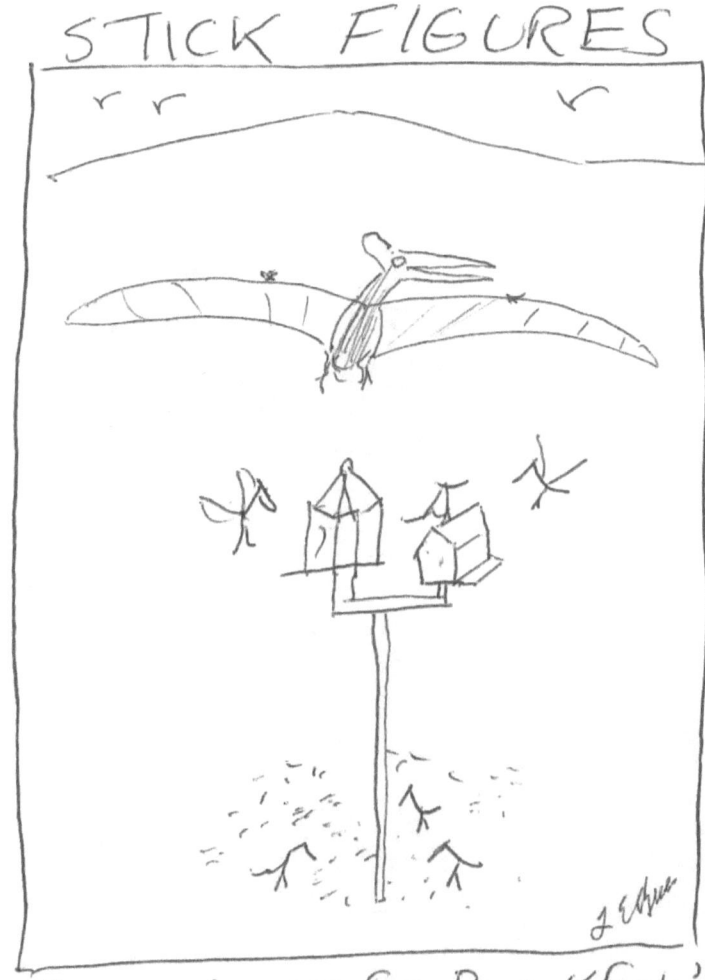

"Pterry Arrives for Breakfast"
from BIRDS OF WEST VIRGINIA

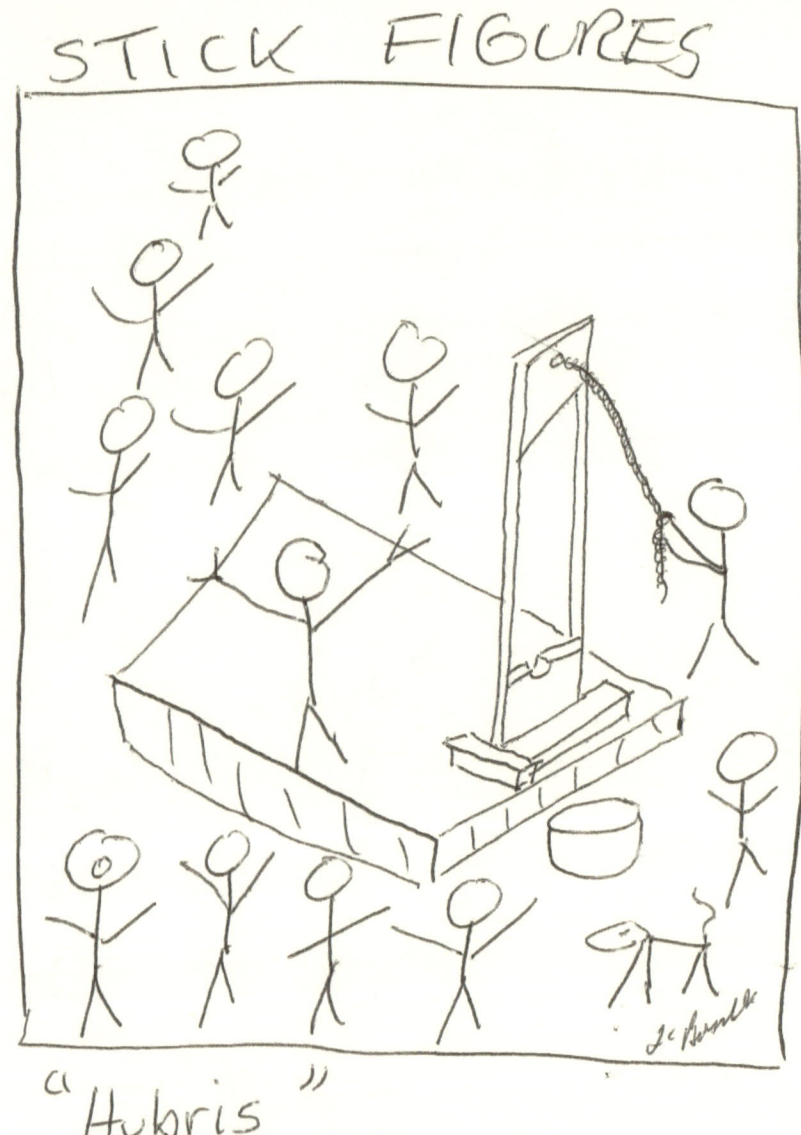

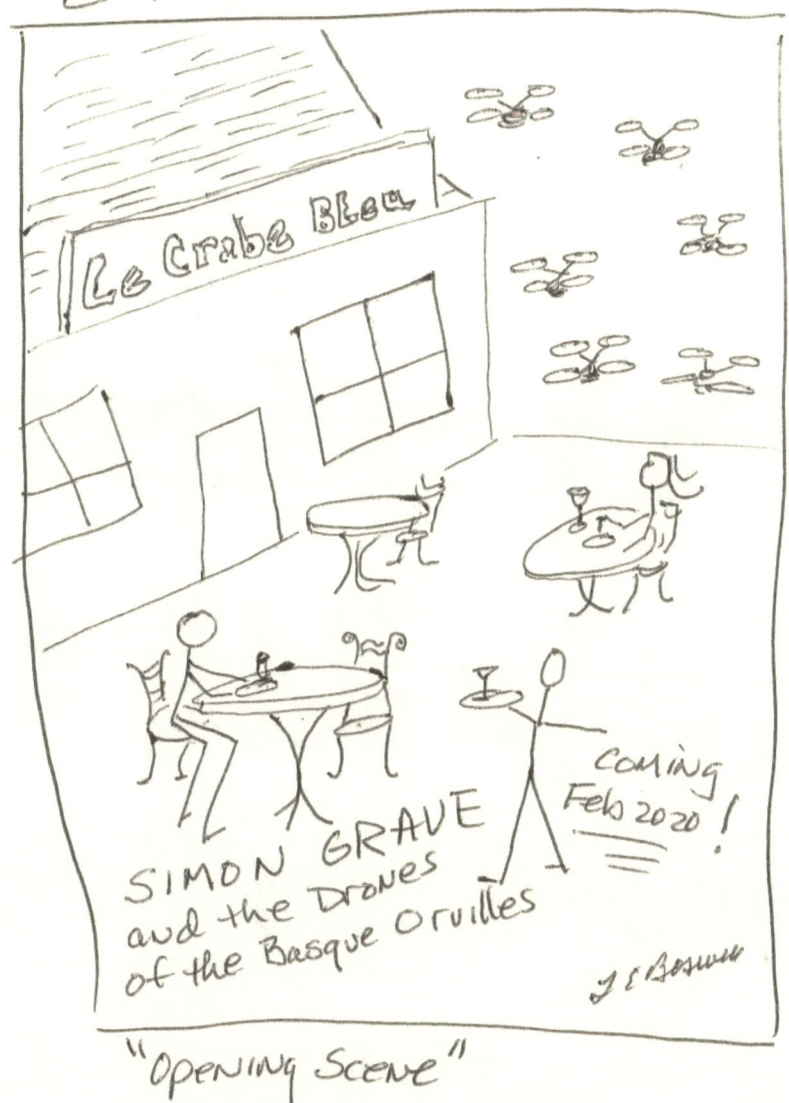

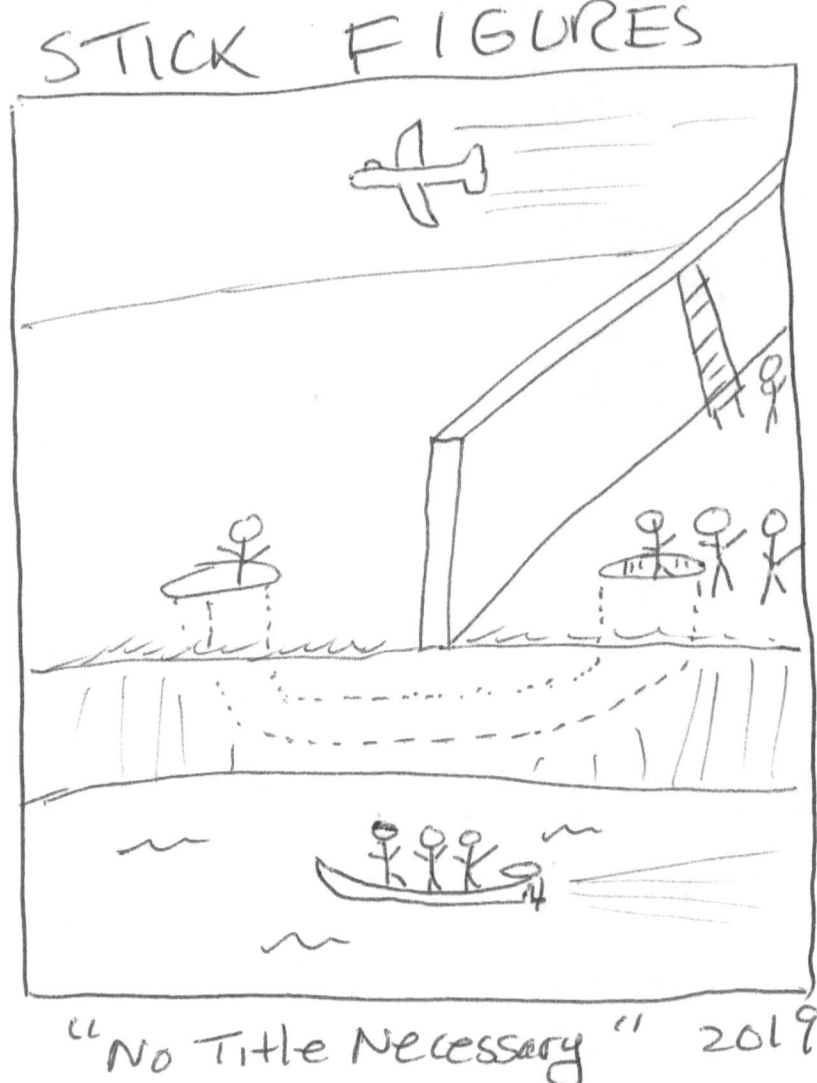

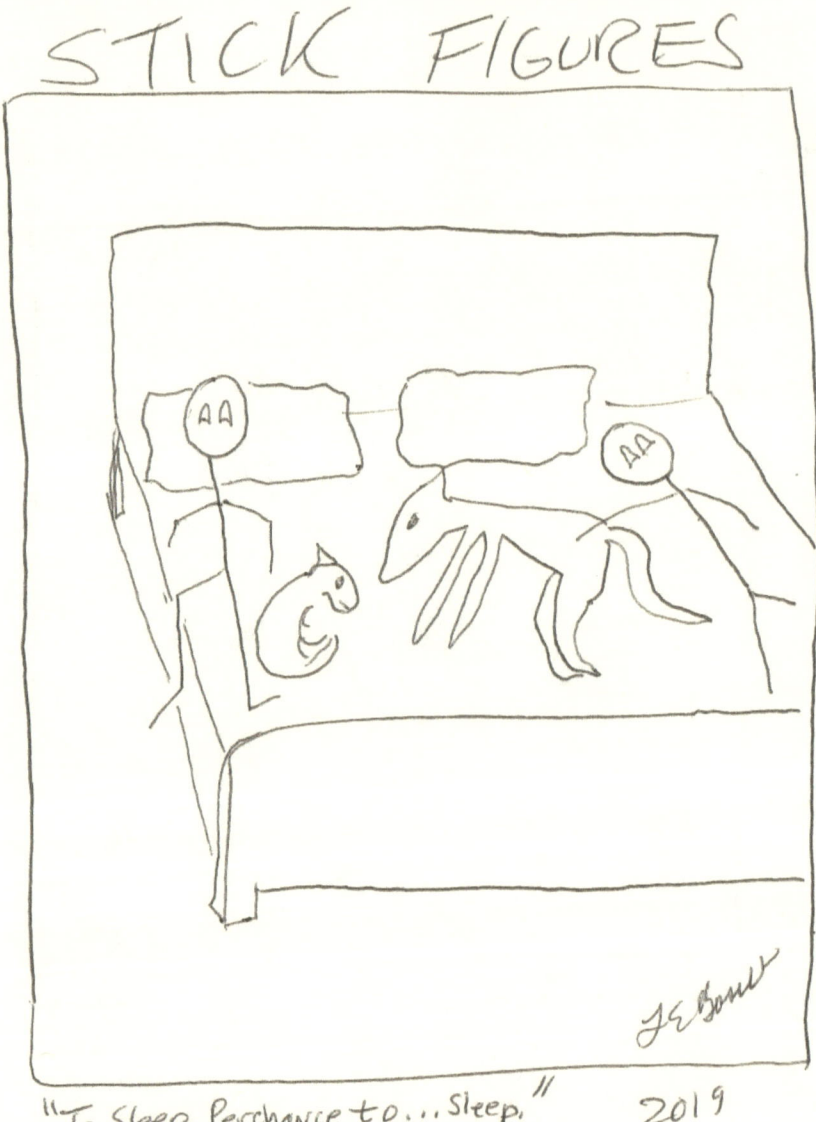

Afterwords

Well, there you have it. I hope you enjoyed this collection of Boswell drawings. As I said at the beginning, they are the merest slice of a body of work unlike any in the history of art. There will simply never be another Boswell.

Fortunately for us, Boswell continues, always striving to do more with less. As I depart Sticklandia, Boswell encourages me to return to see his future works. I know I will, and I encourage each and every one of you to book a flight to Sticklandia. The people are friendly, the herring is superb, and the martinis are to die for. Just try not to worry about the landing. Let me tell you, Sticklandian pilots are the best in the world, and know how to stick a landing. And yes, they expect you to scream, so go for it.

But wait, there's more. The Sticklandia Chamber of Commerce insisted I include the drawing that follows. In addition, Boswell insisted I include the first chapter to *A Grave Misunderstanding*, the first book in his Simon Grave Mysteries series. I do hope you'll read it. It's quite good, and reflects all the whimsy and word play you've found here in this little book. And it was a Finalist in the American Fiction Awards. And, it was a first-place winner in the PenCraft Awards for Literary Excellence. Not bad, huh? Enjoy!

Buh-bye. (For now)

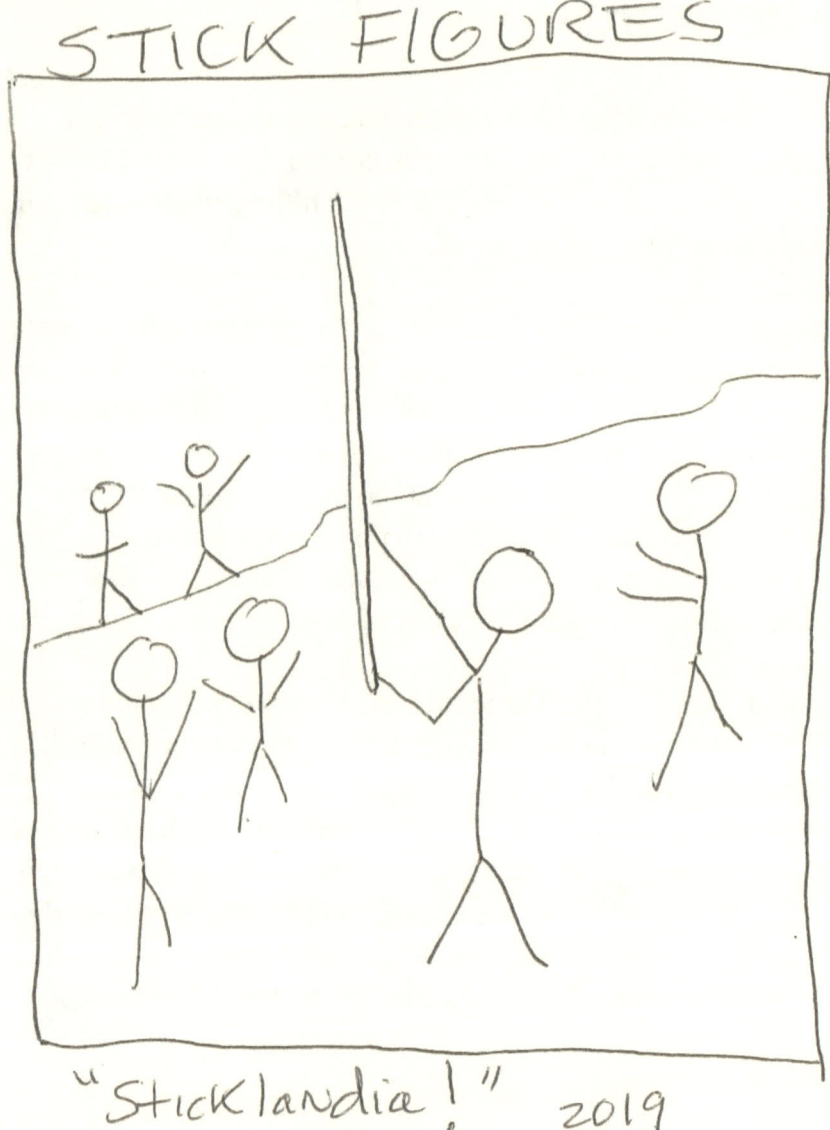

A GRAVE MISUNDERSTANDING

1

Her naked body was displayed just so, arms and legs splayed like a paper doll, head gently resting on the bottom step as if she had slid down the staircase on her back, blond hair carefully fanned out to form a waterfall to the foyer floor, a single red rose placed between her teeth in a way that suggested flamenco dancing, a child's suction-cup arrow sticking out from her forehead, and most disturbing, an emoji painted on her belly with red paint, its eyes crosses, indicating death, its mouth the poor woman's belly button, giving the emoji a look of both surprise and dismay. All this gave Detective Simon Grave the distinct feeling that lunch would be delayed.

Simon Grave had been a detective in Crab Cove for more than twenty years, and in all those years, he had never once had a case involving a murder in a mansion. So as thrilling as it was to see a body sprawled on a staircase with more steps than the Washington Monument, under a chandelier capable of lighting Dubuque, Iowa, he had grave misgivings that the CSI folks, a crew capable of almost nothing, would be up to the task at hand.

As for hands, he couldn't help but notice that the victim had only one, at least within her reach. The severed hand lay several feet away, looking gray and bloodless, like a dead fish washed ashore on a beach in Detective Grave's price range. Jeremy Polk, the medical examiner, was poking at it with a Q-tip and making little headway in reanimating it.

"I say, Polk, what do you make of all this?"

Polk stopped poking the hand and looked up at Grave. "You mean the body or those annoying people knocking on the door of the locked room upstairs?"

"The body, of course." He wasn't ready to discuss the locked room and the people within, despite the rapidity and forcefulness of their knocking, not to mention the strident though muffled obscenities they were yelling and screaming through the door, which his trained ear noticed was reverberating within the tonal range of aged mahogany. The fact was, he had only dealt with murders where the locked room contained the victim, not what may be all the prime suspects.

Polk set down the Q-tip and groaned his way to his feet, drawing his body to its full height, which wasn't much. He was an altogether short man by any measure, but there was something about his posture—back rigid, chest thrust out, head tilted to one side, chin up, nose high, lips curled into an arch snarl, one brow higher than the other—that suggested he might be almost an inch taller and certainly a man to be reckoned with, if not taken seriously, particularly on a weekend. In short, if "height" was a hot air balloon soaring above the desert, Polk was a small cactus staring up at it.

"You can see the body right there, Grave."

"Yes, of course, but what do you make of all these clues?"

"Clues?" said Polk, shaking his head dismissively. "In case you haven't noticed, it's all about DNA these days. All we have to do is take DNA kits upstairs, collect samples from the likely suspects, match their DNA to the evidence from and around this unfortunate young woman, and we'll have our killer. Ipso facto, e pluribus unum."

The medical examiner had then laughed in a way that gave Detective Grave pause. He was unsure about the nature of the laugh. On the one hand, it was pure sardonic mischief, while on the other hand it had all the qualities of a dismissive chuckle. He could have gone on to third and fourth hands, but he preferred to be anatomically correct in such matters.

"Polk, I fully recognize the relentless intrusion of science on criminal detection, but remember, DNA spelled backwards is AND. There's always something else, there's always an *and*, whether it's a careless remark or something as simple as a poorly timed laugh, there's always something else to hoist the criminal on his own petard."

Polk rolled his eyes and laughed a second time. "Well, say what you will, Grave, but I'd rather bring DNA evidence to court than a poorly timed laugh."

This second laugh was clearly dismissive, coming as it did with eyes that seemed to roll hard, like dice thrown down a craps table by a man down to his last toss, set to lose everything, including the blonde on his arm.

Grave tried his best to shake off the troubling image. Polk with a beautiful blonde? Ridiculous. He decided to move on. "Is there anyone else around?"

"Just me and the usual carnival of uniforms," said Polk, sweeping his arms around the room to take in what must have been a dozen uniformed officers, each trying their best to look busy, but most just gawking at the interior of the mansion and looking forward to describing it to their wives or girlfriends.

"No, I mean, if *everyone's* locked in that room upstairs, who called this in?"

Polk couldn't believe his ears. "What? Have you never heard of cellphones?"

Grave hated to be caught in a logical mistake, particularly by a man like Polk. "Er, yes, of course."

Polk laughed again in a way that might be classified a curt guffaw, coming out as it did like the bark of a small dog.

"Well, as it turns out, there was no emergency call, at least from the crazy stupid people upstairs. Turns out, the lord of the manor here didn't turn up for his tee time at the country club, which some of his golfing buddies considered tantamount to murder. One thing led to another, a patrol car was dispatched, etcetera, etcetera, and here we are with a beautiful dead woman on a Saturday morning. Oh, and shortly after we arrived, we received an email from someone upstairs."

"I see," said Grave. "I'll leave you to your precious DNA, then." He turned on his heels and started climbing the stairs, which seemed to lead endlessly upward to some insanely artistic vanishing point.

Polk laughed yet again behind him. "You can't accept the primacy of DNA, can you?"

"I can't, shan't, wan't," he said, continuing to proceed up the stairs without looking back.

"You know," said Polk, "that *wan't* isn't a word."

Grave paused on the stairway and looked back at Polk. "How would you know without checking its DNA? And besides, it rhymes."

He continued walking up the stairs, the silence from Polk nearly unbearable. He made a mental note to brush up on his skills in rational argument, at least where contractions were concerned.

After a few more steps, he paused again to give his throbbing legs a rest and to look back on the crime scene. Even at 30,000 feet, the approximate height of the mansion's staircase, a crime scene could reveal important clues.

In Grave's experience, murder was often the result of a misunderstanding, of fact, situation, or intent. And the more grave the misunderstanding, the more chaotic the crime scene, indicating a level of passion, whether from hate or love, disproportionate to the perceived slight. But the crime scene he was looking at here, even from this rarified altitude, was not chaotic at all. In fact, it was clearly a planned, and laughably overwrought, tableau.

The pounding coming from upstairs continued unabated. He climbed on, his stomach rumbling from hunger.

Available in paperback, ebook, and Audible.

Other books by Len Boswell

Simon Grave Mysteries

A Grave Misunderstanding
Simon Grave and the Curious Incident of the Cat in the Daytime
Simon Grave and the Drone of the Basque Orvilles (Feb 2020)

Other Mysteries

Flicker: A Paranormal Mystery
Skeleton: A Bare Bones Mystery

Fantasies

Barnum's Angel (Fall 2020)

Creative Nonfiction

The Leadership Secrets of Squirrels

Memoir

Santa Takes a Tumble

About the Author

Sticky Stickerson, Sticklandia's self-proclaimed "Ambassador of Art," is the author of too many art books to mention. He is currently the curator of the Boswell Gallery of Stick Art, which is located just off the lobby of the Stickler Express motel, where you can also buy candy and other refreshments.

He views the current work as his highest achievement, second only to drinking a herring martini during landing at the Sticklandia Airport—without spilling a single drop!

But enough about him.

www.ingramcontent.com/pod-product-compliance
Lightning Source LLC
Chambersburg PA
CBHW032011170526
45157CB00002B/642